THE BEGINNER'S GUIDE
-TO-
Procreate

EVERYTHING YOU NEED TO KNOW TO MASTER DIGITAL ART

Roché Woodworth

Creator of Roché Woodworth Illustration

PAGE STREET
PUBLISHING CO.

PAGE STREET
PUBLISHING CO.

First published in 2023 by
Page Street Publishing Co.
27 Congress Street, Suite 1511
Salem, MA 01970
www.pagestreetpublishing.com

Distributed by Macmillan, sales in Canada by The Canadian Manda Group.

27 26 25 24 2 3 4 5

ISBN-13: 978-1-64567-938-7
ISBN-10: 1-64567-938-1

Library of Congress Control Number: 2022952255

Cover and book design by Molly Kate Young for Page Street Publishing Co.
Illustrations and Photography by Roché Woodworth

Procreate is a registered trademark of Savage Interactive Pty Ltd., which does not sponsor, authorize or endorse this book.

Printed and bound in the United States of America

Page Street Publishing protects our planet by donating to nonprofits like The Trustees, which focuses on local land conservation.

Dedication,

TO MY WONDERFUL HUSBAND, CODY,
AND MY THREE SILLY BOYS,
BO, BEN AND JAMIE

Contents

Introduction

Hi, I'm Roché, a digital artist!

Since the release of the original iPad Pro© in 2015, there has been a massive boom in a brand-new breed of artists! The iPad artist. The Procreate® artist! I am one of them.

While I've been dabbling in art my entire life, it was only with the release of this fantastic device that I dove headfirst into the wonderful world of digital art. Fast-forward six years, and here I am writing this book, which is a dream come true!

This is the kind of book I wish I had as a beginner. It would have been so incredibly helpful to me in those first weeks and months trying to navigate this amazing new world.

Over the years, I've hunted all over the place for information, and learned from countless artists, books, blogs and videos. I've taken in everything I could find, and then I figured out how to simplify my style and workflow.

Now, I've taken all that information, everything I know, and put it all in one place: A book that you can refer back to again and again. I'm throwing in every tip and trick I've learned throughout my digital art journey, from being a complete newbie struggling to figure out Procreate to being a proper digital artist who makes a living drawing cute pictures. What?!

I hope this book guides you to being the digital artist you dream about being, and I can't wait to see what you create with everything you learn.

Happy learning and happy drawing!

NOTE: Even though this book features an iPad and Procreate, you can follow along with any app you want. Most digital art programs have all of the same essential tools and functions. You might find them in a different spot, and they might look and work a bit differently, but they can create the same effect in the end.

Roché Woodworth

How to Use This Book

I know you'd love to jump right in and start creating cute illustrations, but I've arranged this book in a way that will be most effective for learning. So, don't skip any chapters! Start at the beginning and work your way through to the end.

You'll begin your journey by learning all the basics about the actual Procreate app, including how to navigate and find the most important tools for beginners, as well as how to use these tools. Please familiarize yourself with the app. You don't have to memorize anything; you can always refer to these chapters if you get stuck! You'll then find a basic overview of a few important art concepts like color theory; highlights and shadows; composition and perspective and lines and texture. Finally, you will head into the drawing chapters. Every drawing chapter starts with an introductory lesson, where I will give you some general pointers, tips and tricks.

A step-by-step project (or more!) follows every lesson, so you can practice what you've learned. The projects build on each other in a sense and increase in complexity. So, some of the later projects contain elements from previous chapters and projects! Doing it this way helps you apply everything you learned in each chapter and project, and eventually you'll be creating your own unique illustrations in Procreate.

The goal of this book is not only for you to become familiar with all the most important tools and functions in Procreate, but to also get comfortable with basic art concepts and drawing skills. That way, you can develop your own style and embark on your own journey as an artist! It's exciting stuff.

So, when you're ready, grab your iPad, open up Procreate and get started!

PART ONE

How to Use Procreate

CHAPTER ONE

Introduction to Procreate

Okay. First things first: Procreate is AMAZING! No, for real.

It is literally a whole art studio you can hold in your hands and take with you everywhere! It is an incredibly complex and powerful app, but at the same time, it's so very intuitive, which makes it the ideal digital art app for both beginners and professionals. It provides such a natural drawing experience, which is absolutely perfect for practicing and learning, because you're not wasting any supplies.

Digital art, in general, is excellent for beginners because it is so forgiving. You can undo and erase any mistakes and try again and again until you get it right.

So, let's see what it's all about! When you first open Procreate, you will see your gallery, which you will soon fill up with your beautiful artworks. At the top right of the screen, you'll find four options.

Gallery

Select Import Photo +

- **Select:** Allows you to select one or more artwork and either stack, preview, share, duplicate or delete the artwork.

- **Import:** Allows you to import files (like .procreate or .psd).

- **Photo:** Opens an image from your camera roll.

- **+:** Creates a new canvas.

Procreate

pink landscape
6000 × 6000px

12 November
2048 × 2048px

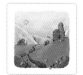
peace landscape
3000 × 3000px

chicken sketch steps
3000 × 3000px

ballerina
3000 × 3000px

love birds
3000 × 3000px

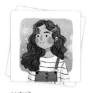
portrait
2 artworks

puppy portrait coloring
3000 × 3000px

scribbles
3000 × 3000px

bunny love
3000 × 3000px

boy puppy
3000 × 3000px

pink cottage
3000 × 3000px

happy flowers
3000 × 3000px

self portrait
3000 × 3000px

photography
210 × 297mm

RENAMING AND ORGANIZING YOUR GALLERY

Tap on the name of an artwork to rename it.

You can sort your artwork into stacks by dragging and dropping them on top of each other.

You can then change the name of a stack the same way you rename individual artwork; just tap on the title to change it!

It's very beneficial to organize your artwork in stacks. Keep different pieces for a project together or, for example, have a sketchbook stack. It keeps things neat and organized (and much easier to find once you start filling up your gallery).

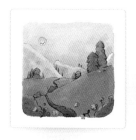
landscape project ⊗

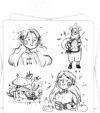
Sketches
5 artworks

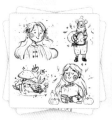
Sketches ⊗

GALLERY GESTURES

There are also a few helpful gestures available on your Gallery screen.

Swiping right over an artwork gives you three options.

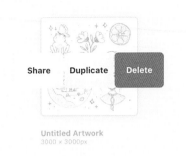

Untitled Artwork
3000 × 3000px

- **Share:** If you tap on this option, you can choose a format to export your artwork in, as well as where to share or save it.
- **Duplicate:** This creates a copy of your artwork. (If you want to play around with an artwork while still preserving the original, this is the perfect way to do it.)
- **Delete:** This option deletes your artwork. (You can't undo this, so be careful!)

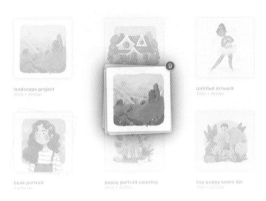

When you long press on an artwork, you can drag and drop to rearrange it. When you long press to drag an artwork, you can also tap on other artworks with another finger to select multiple pieces at once. Rearrange them this way or stack them together.

Setting Up Your Canvas and Technical Details

ADDING A NEW CANVAS

Tapping the "+" button on the Gallery screen brings up the New canvas menu. Procreate comes loaded with a few commonly used canvas sizes like screen size, square, A4, 4K, 4 x 6 photo, paper, comic, etc.

I stick to the 3000 x 3000px square setting at 300 DPI for all the work I intend to post on Instagram. These canvas settings are kind of overkill for social media or web use but perfect if you need to print an illustration. That said, I would initially stick to one of the default canvas presets. Later on, if you have a specific project you're working on that needs particular dimensions and settings, you can create it then!

NOTE: DPI stands for "dots per inch." It refers to the resolution of an image or how many little dots of ink can be printed per square inch, which affects the sharpness and quality of your image when printed.

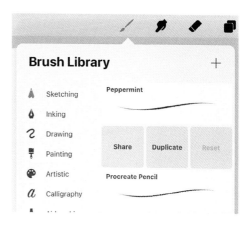

CREATING A NEW CANVAS

In the upper right-hand corner of the New canvas menu, you'll find a "+" icon that allows you to create a custom canvas.

This will take you to a screen that allows you to set the dimensions or size of your canvas, the color profile, time-lapse settings and canvas properties. This is a can of worms you don't need to get into as a beginner!

The only things you need to worry about at first are the actual dimensions of the canvas.

THE USER INTERFACE

The Procreate user interface is incredibly simple and intuitive.

On the right of the top bar, you'll find all the options for actual painting.

- **Paint:** Allows you to create beautiful digital art with an incredible selection of digital brushes.

- **Smudge:** Blends and mixes colors.

- **Eraser:** Fixes any mistakes.

- **Layers:** Creates layers and allows you to change, delete or move specific elements in your drawing.

- **Color:** Allows you to choose colors and find and save color palettes, color harmonies, etc.

On the left of the top bar, you'll find a "Gallery" button to take you back to your gallery screen, and then four buttons that give you more adjustments and control over your canvas! These are, from left to right:

- **Actions:** Here you'll find lots of technical and practical tools including insert elements, canvas settings, export and share, time-lapse videos, app preferences and help.

- **Adjustments:** This is where to go to add any final details and adjustments to your drawing, whether it's changings colors or creating cool special effects.

- **Selection tool:** There are lots of advanced options available here, but it all boils down to being able to select and isolate a specific element or section of your drawing to make changes or adjustments to that part only.

- **Transform tool:** Use this to move things around, resize or warp.

You'll find a sidebar to the left of the screen.

The top slider changes the size of your brush.

The "modify" button defaults to the eyedropper tool but can be customized in Settings.

The bottom slider is used to change the opacity or transparency of your brush.

The "undo" and "redo" arrows (the beauty of digital art!) let you make quick changes.

The Most Important Tools You Need to Know

ACTIONS

Here are the six functions available in the Actions menu.

Add

Here's where you can insert a file or photo and add text to your canvas. You can also cut, copy, copy canvas and paste. I use Insert a photo, Add Text and Copy canvas a lot.

What's the difference between Copy and Copy canvas?

You'll use Copy to copy a specific layer or a specific selection on your canvas. Copy canvas copies everything currently visible on your canvas, regardless of layers. It copies the entire image on your canvas. Often, I use Copy canvas to copy and paste my finished illustration onto one new layer to do global color adjustments or to use the liquify tool to adjust anything that looks wonky.

I also use the Selection tool from the Gallery screen to select an element on my canvas that might consist of multiple layers, and choose "Copy canvas" instead of "Copy." That way, I'm copying the entire element—everything that's visible on the canvas—instead of just the currently selected layer.

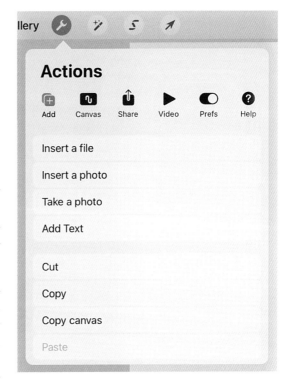

Insert a Photo and Insert a File

Often, it's helpful to import your reference photo onto the canvas instead of using Procreate's built-in reference tool. This is great for those instances when you'd like to use the eyedropper tool to pick colors directly from your reference photo.

Selecting "Insert a photo" will open your iPad camera roll, whereas selecting "Insert a file" will open your files app.

Add Text

Sometimes, I create illustrations that need text; that is where the Add Text function comes in handy! It's an easy and straightforward tool. Tapping "Add Text" will add a box with the word "text" in it. You can move the box around with the selection tool and resize it.

When you tap on the "Aa" button on the top right-hand corner of the keyboard pop-up, you get some customization options, like picking the text's font, style, design and attributes.

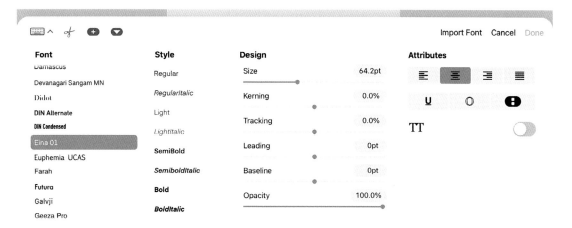

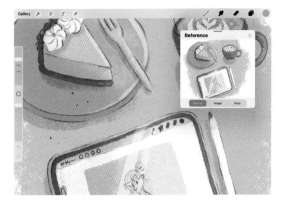

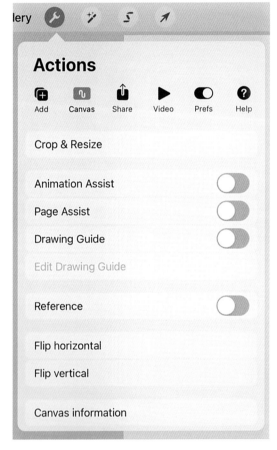

Canvas

Here are the tools you'll find when you tap "Canvas."

Reference

The most important one to be aware of when starting out in Procreate is Reference, which is where you can import an image to refer to as you're drawing.

Tap on "Reference" to turn it on, then you can choose one of the following options:

- **Canvas:** Reference your whole drawing while you're zoomed in.

- **Image:** Import an image to reference while you're drawing.

- **Face:** This function opens your iPad's front camera and shows anything that's on your canvas molded to your face. It is very handy when creating cute camera and facial filters for Instagram, but it can give you a jump scare when you're not! Think of it as digital face paint.

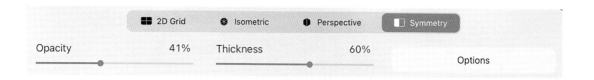

| 2D Grid | Isometric | Perspective | Symmetry |

Opacity 41% Thickness 60%

Options

Drawing Guide

Turning on the Drawing Guide allows you to create different guides over your canvas to help with lining things up with a grid, isometric grid and perspective point. You'll also find the Symmetry tool, which places a line over your canvas, and then mirrors everything you draw on one side of the line on the other side. You can find these options for different drawing guides when you tap "Edit Drawing Guide."

Selecting "Flip horizontal" or "Fip vertical" flips your entire canvas "left, right, up or down." This function is fantastic for seeing if there's anything wrong with your illustration. When drawing, your eyes get used to what you're looking at, and it's sometimes impossible to see any wonky parts until you flip the canvas. It's freaky how things look super good, and the second you flip the canvas, all your mistakes jump out at you!

This happens because your brain gets used to the mistakes, and when you flip the canvas, it forces you to view your illustration with new eyes because mistakes or distortion are now magnified!

Normal

Horizontal flip

Vertical flip

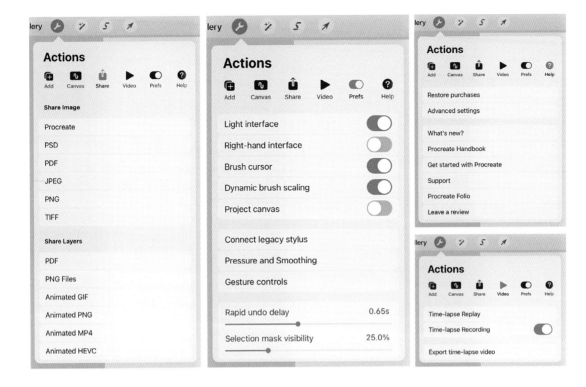

Share

Here is where you can export your illustration in a variety of file types, and then save it to your Photos app or share it in various ways.

To export a flat image, choose the file options under the Share Image header. Or to export a layered file that you can export into another drawing program, select the file options under the Share Layers header. You can also export animated GIFs.

Video

Here, you can watch and export your time-lapse video.

Preferences

In the Preferences section, you'll find all kinds of general settings and adjustments for the app, pen pressure and gestures. You don't need to worry about most of these, unless you have a very specific usability problem that you're running into.

If you'd like, you can switch the toggle to change from a dark to light interface. Or, if you are left-handed, you might like to switch the interface. To do that toggle the "Right-hand interface" option to off.

You can also select "Gesture controls" to see ALL the gesture options available.

Help

This section is self-explanatory. You'll find Procreate's help files and some select advanced settings that you most likely don't need to worry about.

Hue	50%	Saturation	50%	Brightness	50%

ADJUSTMENTS

In this section, you'll find everything you need to make adjustments to your actual illustrations as well as create some cool special effects!

The ones you'll probably use most are color adjustments hue, saturation and brightness.

- **Hue:** Adjusts the actual color on the color spectrum.
- **Saturation:** Adjusts the dullness and brightness of the color.
- **Brightness:** Adjusts the lightness and darkness of the color.

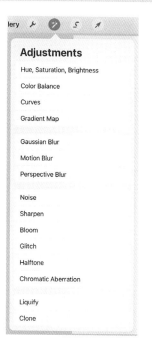

Adjustments

Hue, Saturation, Brightness

Color Balance

Curves

Gradient Map

Gaussian Blur

Motion Blur

Perspective Blur

Noise

Sharpen

Bloom

Glitch

Halftone

Chromatic Aberration

Liquify

Clone

Gaussian Blur creates an even all-over blur. This can be good for blurring close-up elements in the foreground of your illustration or things that are blurred and faded in the background.

The Noise function creates randomized brightness adjustment of individual pixels, and this gives the illustration a grainy, papery look.

Using Sharpen adds extra contrast between light and dark areas of the illustration to make it feel sharper and crisper.

The Liquify tool allows you to use the pen to adjust and manipulate your illustration in various ways.

The options for the Liquify tool are Twirl Right, Twirl Left, Pinch, Expand, Crystals, Edge and Push. In the example, I've drawn a seven-point star, and then tapped and held my pencil to the screen for 2 to 3 seconds to show the effect of each of the options.

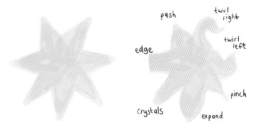

The Liquify option I use most is Push, which I use to make minor adjustments to my illustration. For example, when I've drawn one ear a bit high, I use this tool to push it down. Or, if I drew a face too round, I push it slightly straighter. It's incredibly helpful for making final adjustments to your illustration without erasing and redrawing anything. Another perk of digital art! You can easily overdo it though, so it's best to use it for small, subtle tweaks! In the example, I've used the Push effect to change the shape of her face, but because I've overdone it, her facial features have become a bit distorted.

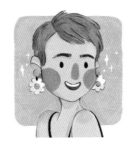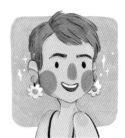

SELECTIONS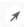

This tool allows you to select and isolate specific sections of your illustration to move around or add effects and adjustments to that little piece only.

The Freehand option is most useful, because you can use your pencil to draw around the piece you want to select.

I use this often to copy and paste elements onto new layers and move things around on the same layer, as well as to resize any specific details of my illustration.

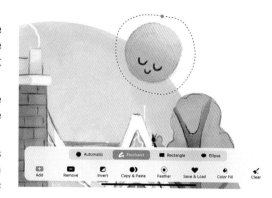

TRANSFORMATIONS

This tool allows you to manipulate a selected element. You can resize it, move it around and even distort and warp it using a grid.

Let's use this cottage as an example. You can use the selection tool to draw around the sun. Then when you tap the transformation tool, you can manipulate the sun in various ways.

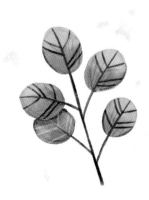

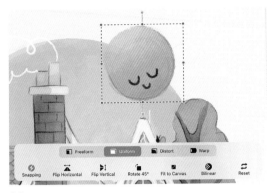

Move

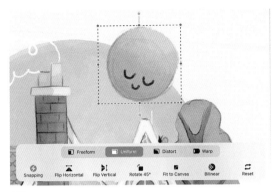

Flip

The Snapping option is helpful when you want to align things because it will "snap" it in line with other nearby elements.

Warp

Important Gestures in Procreate

There are many gestures available in the Procreate app, but the single most helpful gesture is the undo and redo gesture.

1. Tap with two fingers to undo, and tap with three fingers to redo. Once you get used to this gesture, you'll catch yourself doing it even when working with an actual pen and paper!

2. A quick pinch gesture fits your drawing to the screen. It's precisely the same as zooming out, but quicker! It's a great way to see your whole canvas fast.

3. Another one you'll use often is long pressing on the canvas to invoke the eyedropper tool. That way, you can easily switch between colors you've already used on the canvas.

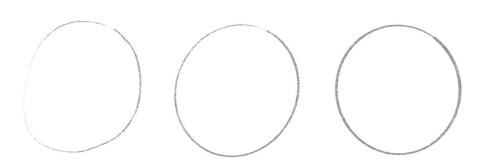

4. The quick shape tool is also a good addition to your repertoire, and it works for lots of different shapes: straight lines, circles, ellipses, squares, rectangles, quadrilaterals and polylines.

For example, draw a circle, and wait for a second before lifting your pencil off the canvas. This will turn your roughly drawn circle into a shape you can adjust. While still holding your pen down, you can then tap with another finger to change the shape into a "perfect" version of that shape!

At the top of the canvas, a button will also appear with the name of the shape you've drawn, allowing you to adjust the type of shape. This quick-shape tool works for most of the basic shapes.

When making shapes, you will also see a new bar at the top of the screen, which gives you the ability to edit your shape.

When you tap the button with the name of your shape, points appear on the shape that you can use to tweak it.

O **Editing** Circle ▾

O Ellipse O Circle

Getting Started

In this chapter, we'll dive into everything you need to know before you start putting pen to paper, or in this case Apple Pencil© to iPad!

Think of this chapter as setting the stage for you to start creating! We'll start by covering all the basics about digital brushes because in the end, it's all about the brushes! Luckily for you, Procreate has, without a doubt, the best selection of digital brushes you could ever hope for.

Color is another fundamental part of digital art—it sets the mood and atmosphere of the illustration. It can be used to create an emotional response from the viewer or to portray depth and light.

Finally, we'll go over layers, which are one of the fundamental (and best!) features of digital art. Layers give you fine control over your canvas and everything on it.

Closely linked to layers are masks and blending modes. These tools help you create amazing special effects with your illustrations that are difficult and, in some cases, impossible to do with traditional art. Just one more reason digital art is so amazing!

Let's take a closer look.

All About Brushes

Tapping on the brush at the top of the user interface page will open the brush library. Here you can find a large selection of beautiful built-in digital brushes that will allow you to create the art of your dreams.

They've got everything you can think of from pencils, pens and inkers to paintbrushes, textures and special effects brushes!

You can also find countless custom-made brushes that are sold by artists online (including me!). But in this book, we'll stick with Procreate's excellent default brushes.

You can also export your own brush sets by long pressing on the brush set name and tapping "Share." This saves a .brushset file to your iPad. You can now share this file with other people any way you like. All you need to do to import a brush set is to tap on the .brushset file. Procreate will handle the rest.

RW_Basic_Marker.brushset
4.1 MB

RW_Inky_Painter.brushset
9.4 MB

SAVING BRUSHES

When you first download Procreate, I suggest starting at the top of the brush library and testing out every available brush. Just make some scribbles on the canvas to see what it feels like.

If you like one, add it to your own Favorites set or pin a brush to the Recent tab.

You can pin a brush to the Recent tab by swiping left over the brush and selecting "Pin." You will only see this option if you're viewing the brush from inside the Recent tab.

You can create your own Favorites set by scrolling up on the sidebar of the brush library until you see a "+" button. When you tap it, you can name your brush set, and then save your favorites as you discover them.

You'll have to manually drag and drop brushes into this Favorites set.

I advise duplicating the brushes you like and moving the duplicate to your Favorites set. That way, you're not messing up any of the default sets. The same goes for tinkering with any of the default brush settings. Duplicate a brush and move or edit the duplicate. A duplicate brush will have a little wavy line in the top right-hand corner.

You can duplicate a brush by swiping left over the brush and tapping "Duplicate." Then it's as simple as dragging and dropping!

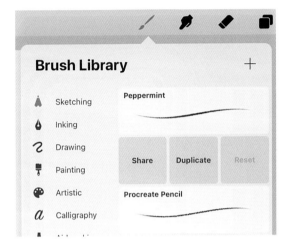

RESIZING YOUR BRUSH

When you pick a brush, you can resize it by sliding the top slider of the sidebar up and down.

If you tap the "+" button, you can save up to four brush sizes to keep your illustration consistent and easily switch between these brush sizes.

On the bottom slider, you can scrub to adjust the opacity of the brush.

You can save up to four different opacity presets in the same manner as the size presets.

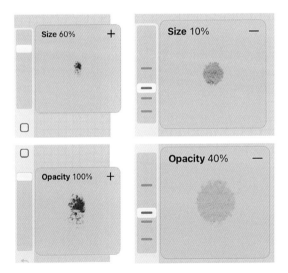

Color Palettes

A color palette is a collection of saved individual color swatches. Each little square on your palette is called a color swatch.

You'll find the Colors menu when you tap the color icon at the top right of the screen. To the bottom right of the color menu, you'll find the Palettes section.

Procreate comes loaded with default color palettes, but you'll probably want to start creating your own immediately!

Tapping the "+" button in the top right corner will create a new color palette. It gives you four options:

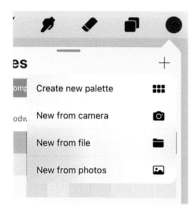

- **Create new palette:** This will let you create a new empty palette.

- **New from camera:** This is a cool feature where you can hold up your iPad camera to anything, and it populates a color palette with what the camera sees.

- **New from file:** Use this if you've downloaded a color palette online and want to import a .color file.

- **New from photos:** This is another fun option to create a color palette from any image on your camera roll.

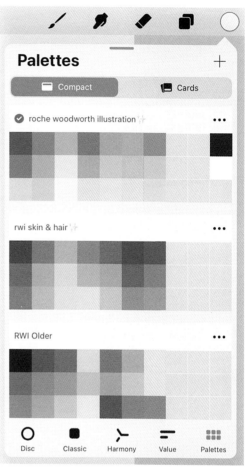

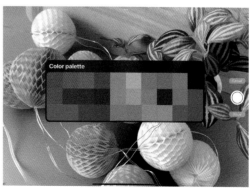

Your camera opens up a whole realm of possibilities.

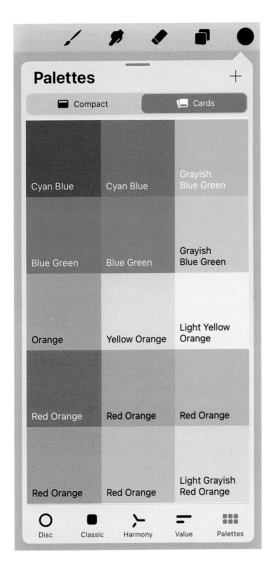

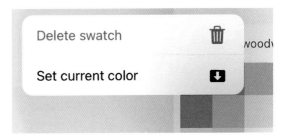

Delete swatch 🗑

Set current color ⬇

With an empty color palette, you can tap an empty square to save any currently selected color. When you long press your swatch, you can either delete it or select "Set current color" to replace it with another color.

You can view your color palettes in either compact or card view. Card view is a larger, extended view of your palette.

Layers, Layer Organization and Tips

You'll find the "Layers" button next to the Colors button in the top right-hand corner of the Procreate user interface.

Layers are one of the absolute best parts of digital art, and the easiest way to understand it is to think of a layer as a piece of transparent paper. Every time you add a new layer, you basically add transparent paper to a stack on top of your canvas.

This means you can draw on one layer without messing up other layers. It also means you can easily change specific elements of your illustration.

For example, you draw a character's head on one layer, and then draw her hair on a new layer. Now, if you hate the hair, you can easily erase and adjust OR completely delete and start from scratch—without messing up the rest of the head or face.

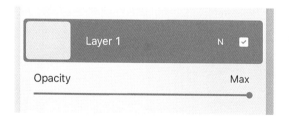

If you're new to digital art, it's definitely worth it to adjust to the idea of using layers, rather than drawing everything on the same paper or canvas as you do with traditional art. Unless you're looking for a challenge, of course!

When starting with digital art, it's best to avoid going overboard with layers! Stick to using just a few until you're more comfortable working in Procreate. Using too many layers can get a bit overwhelming and confusing.

ADDING NEW LAYERS

When you tap on the "Layers" button, a drop-down will appear. This shows your canvas (or background) layer, with all other layers stacked on top.

When you tap the "+" button, a new layer will be created above the selected layer.

Layer Adjustments

Each layer has a checkmark. Tapping the checkmark will hide or turn the visibility of that specific layer on or off.

To the left of the checkmark, each layer has a letter. It defaults to "N," which means normal. When you tap on the "N," a new menu will appear, enabling you to pick a different blending mode. (More on that in the Blending Modes on page 36.) This menu will also allow you to adjust the opacity of the layer with a slider.

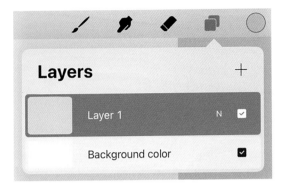

Finally, when you tap on the "Background color," it will open the color picker, enabling you to choose a color for your canvas.

Layer Menu

Tapping on the name of the layer (which defaults to the layer number) will bring up a new menu that enables you to do several things like:

- Changing the name of the layer for better organization
- Selecting the contents of the layer
- Copying the contents of the layer
- Filling the layer with the currently selected color
- Clearing or erasing the entire layer
- Turning on Alpha Lock
- Inverting the contents of the layer
- Selecting the layer to be a reference layer.

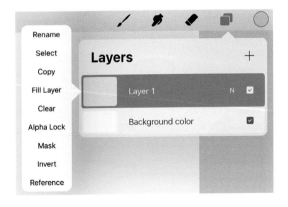

Renaming Layers

What's most helpful in this menu is renaming your layers! And that will probably be the option you use most as a beginner.

It's always a good idea to rename your layers, especially once you get comfortable using LOTS of layers. That way, it's easy to find the layer you're looking for when you want to make any adjustments.

Make it an automatic part of your process; you'll be very happy you've cultivated that habit later on.

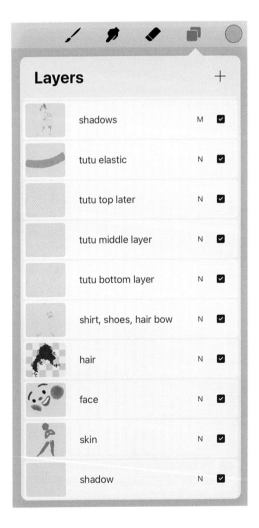

SELECTING LAYERS

Selecting a layer is as simple as tapping on the layer. You can select multiple layers by swiping right over each layer with one finger.

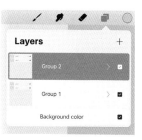
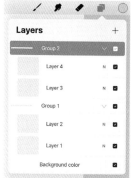

To rearrange your layers, all you need to do is long press, and then drag and drop to where you want the new layer to be. You can move one layer or move multiple at once.

Grouping Layers

When creating complex illustrations with various aspects, it's also smart to group your layers. For example, you can group all the layers of your background. Then group all the layers that make up each character, animal, or object.

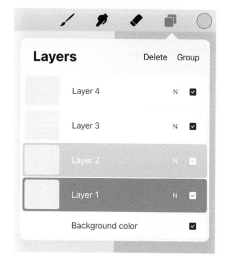

When you select multiple layers, a new option will appear in the top right corner of the Layers dropdown called "Group."

When you tap that option, it will group the selected layers together.

Not only does this help with keeping things tidy and organized, but it also helps with moving and transforming various layers simultaneously.

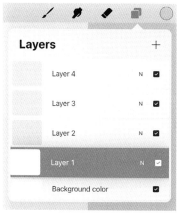
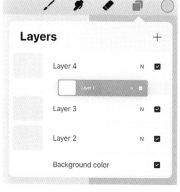
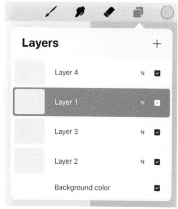

Combining Layers

It might sometimes happen that you go overboard with creating layers for every separate part of your illustration and run into the problem of having too many layers to keep track of. Or your iPad may literally run out of memory, and you get the "maximum limit of layers reached" message on Procreate.

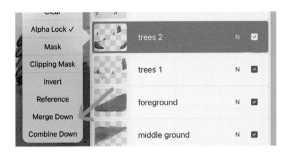

In this case, you might want to combine some layers!

For example, suppose I have lots of trees in a landscape illustration, and I've drawn many on separate layers. In that case, I might consider combining those into a single trees layer.

With that specific example, I will make sure that none of the trees overlap before combining so that I can still go back and make changes to a particular tree without messing up any others.

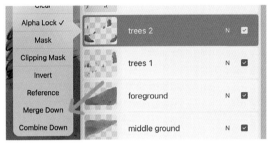

You've got a couple of options if you'd like to combine two or more layers. You can either tap on a layer and choose "Merge Down," which will combine that layer and the one directly below it into one layer. You can also pinch two layers together with your fingers.

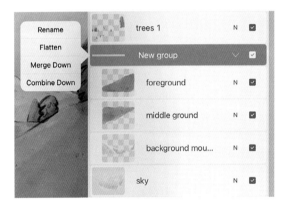

You can also make the pinch gesture with a larger stack of layers.

If you've got several layers in a group, tap on the group name and choose "Flatten" from the pop-up menu. This will flatten every layer in a group into a single layer.

Pinching two layer groups together will flatten everything in the groups together into a single layer as well!

CLIPPING MASKS AND ALPHA LOCK

Masks are a great tool that can give you different ways to modify elements of your drawing without affecting any of the other layers. This can make specific tasks easier (like being unable to color outside the lines) and allows you to experiment without messing up your illustration in any way. In this book, we won't dive deeply into using regular masks since it is an advanced feature that isn't necessary with simpler illustrations.

Clipping Masks

Two functions that I used A LOT in my personal work are Clipping Masks and Alpha Lock. They work in a very similar way, but there are some key differences.

A Clipping Mask is a layer attached to the layer directly below it. It is visualized in the layers menu by indenting the Clipping Mask layer and an arrow pointing down to its base layer.

Anything drawn on a Clipping Mask will only be visible on the shape drawn on your base layer.

If you look at the example you'll see that I drew a circle on the base layer and a wavy line on the Clipping Mask. Only the part of the wavy line that intersects the circle is visible on the canvas.

This is a great way to experiment with textures and colors without changing your base layer! It's also great for adding highlights and shadows to individual objects or elements on your canvas.

If you decide you don't like what you've drawn, you can turn off or delete the Clipping Mask layer, and your base is back to what it was originally.

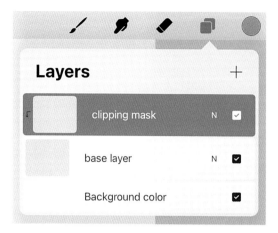

Alpha Lock

Alpha Lock is a function that "locks" any shape you've drawn on a layer. You can now only paint on or change this shape. A great way to think about it is when you Alpha Lock a base shape, it's impossible to color outside the lines! It's also great for recoloring an element of your illustration without changing the outlines. To use this function, tap on the layer and then select "Alpha Lock."

You can also swipe right over the layer with TWO fingers to turn it on or off.

You'll know Alpha Lock is on by the checkered pattern behind the drawn object now visible in the layer preview.

So, if you compare this example to the clipping mask example, you'll see that you've drawn the wavy line directly on the base shape.

With Clipping Masks, you can remove the wavy line by turning off or deleting the clipping mask layer. With Alpha Lock, you'd have to draw over the wavy line or erase it to remove it.

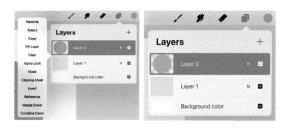

BLEND MODES

Blend modes are essentially different ways one layer can interact or blend with the colors and objects on the layers below it.

In digital art, and with most drawing programs, your blend mode will always default to Normal. Normal means that what you draw on a layer will cover whatever is on the layers below it. In Procreate, you find the list of different blending modes in the layers dropdown menu. On each layer, you'll see the letter "N." When you tap this "N," a list of blending modes will appear. There are many: Multiply, Darken, Color Burn, Linear Burn, Darker Color, Normal, Lighten, Screen, Color Dodge, Add, Lighter Color, Overlay, Soft Light, Hard Light, Vivid Light, Linear Light, Pin Light, Hard Mix, Difference, Exclusion, Subtract, Divide, Hue, Saturation, Color and Luminosity.

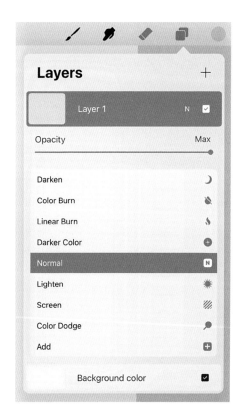

This means that when you change a layer's blend mode to one of these options, the contents of that layer will blend with the contents of any layers below that layer in a unique way.

Most Helpful Blend Modes

There is a long list of different blend modes, and you can play around and have fun with all of them. There are only two I use all the time, and they're also two of the most popular ones overall.

Multiply

Multiply blend mode multiplies and blends the color on your Multiply layer with the color on the layers below. This results in a darker, more intense color. A layer set to Multiply blending mode is a great (and easy!) way to create shadows for your illustration.

Overlay

Overlay is a great way to add contrast and brightness to your illustration. This happens by the shifting mid-tones when colors on the different layers blend. I often use this blend mode to add highlights to my illustrations.

In the example to the right, you'll see three overlapping green circles, each on its own layer. The left circle is set to Multiply and the right is set to Overlay. So, where these circles or colors overlap, they are blended in two different ways. It's evident in this example why Multiply works for shadows and why Overlay works great for highlights.

I've also provided examples of other blend modes to show you how they affect the layers below them.

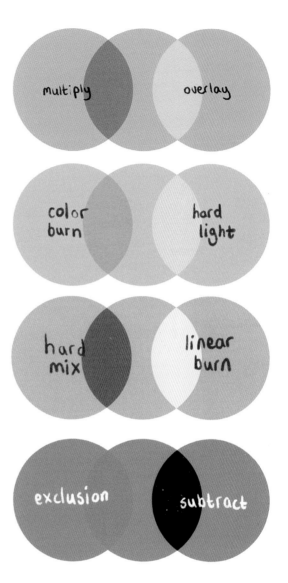

PART TWO

Let's Draw!

CHAPTER THREE

The Basics

Now, it's time to learn a few fundamentals of art! When you know the basics of color theory, highlights and shadows, composition and perspective and lines and textures, you're ready to start creating with a solid foundation!

In this book, we're covering a variety of beginner-friendly techniques, drawing processes and workflows. With the step-by-step projects, you'll encounter a few different ways to approach things, specifically when it comes to coloring and adding highlights, shadows and textures.

I took this approach so you can try out a few different techniques to help you decide what feels best. The goal is for you to figure out the workflow that is most efficient for your style of art and creative process, but this is only possible after lots of practice and drawing.

Basic Color Theory

Color theory is all about the science of color!

Knowing basic color theory will go a long way toward making your illustrations look prettier and more harmonious. It's important to know that although color theory creates specific "rules," these are not set in stone. It's better to approach them as guidelines and not something that blocks your creativity in any way!

The most important things to understand when working with color in Procreate are hue, saturation and brightness.

WHAT IS HUE?

Hue is the actual color, the pure pigment! Our eyes only recognize three primary hues: red, yellow and blue.

When you mix two primary hues, you end up with secondary hues: orange, green and violet.

In between all the primary and secondary colors, are the tertiary hues. Not all the tertiary colors have proper names, but they are generally referred to as red-orange, yellow-orange, yellow-green, blue-green, blue-violet and red-violet!

These primary, secondary and tertiary colors come together to create the color wheel!

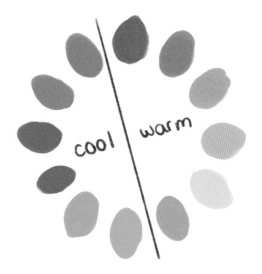

COLOR TEMPERATURE

The color wheel can be divided into warm colors and cool colors.

Red, orange and yellow are generally considered to be warm. These colors usually evoke feelings of happiness. They can also show passion, danger or anger.

Blue, violet and green are cool. These colors give a calming vibe but can also trigger feelings of sadness.

My favorite way to use color in Procreate is with the Classic Color Picker. That way, you've got easy and precise control over the hue, saturation and brightness. You can see all the different ways to use color in Procreate at the bottom of the Colors dropdown. They are: Disc, Classic, Harmony and Value.

Disc Classic Harmony Value Palettes

COLOR HARMONIES

Color harmonies are names given to specific combinations of colors that are generally pleasing to our eyes. They are considered harmonious and aesthetically pleasant. When using Procreate, you're in luck, because there's a special section on the Color menu specifically for this purpose.

When you tap the "Color" menu, you'll see a section called Harmony at the bottom.

When you tap on the word underneath the word "Colors," a menu will appear, allowing you to choose between five popular color harmonies:

- Complementary
- Split Complementary
- Analogous
- Triadic
- Tetradic

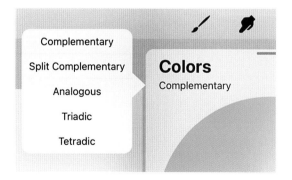

In the examples below, I've used the same peachy color to try out the different harmonies. Because the peachy color is very light and bright, the colors that match with it on the color wheel can sometimes feel a bit too bright. Right below the color disk, you'll find a brightness slider, which you can use to adjust the brightness to better fit your palette.

In some of the examples, I've lowered the brightness and found more pleasing versions of those colors and drew them next to the original.

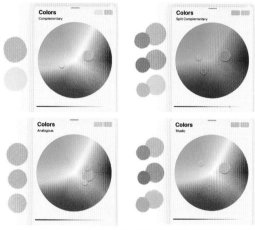

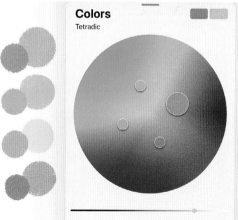

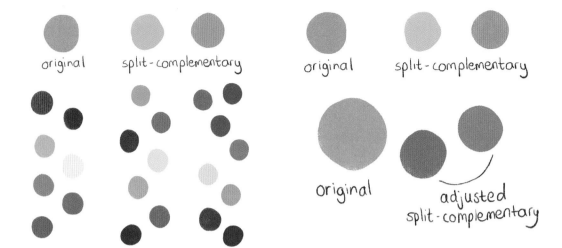

The wonderful thing about color harmonies is that once you've matched, for example, three split-complementary colors, you can now use different versions of those three colors by adjusting the brightness and saturation of the color (not the hue!) so that you have a lot of variety to work with.

All of these colors still have the exact same hue; they are the same core color. So, even when you play around with their saturation and brightness, they still stay split-complementary. By adjusting the saturation and brightness, you can create more aesthetically pleasing versions of these harmonies that match the mood of your illustration.

Complementary

Complementary colors are two colors that are exactly opposite each other on the color wheel. Using them together can be eye-catching and great for making something stand out when used correctly.

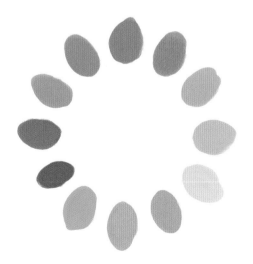

Split Complementary

Split complementary color palettes consist of one key color and TWO adjacent colors on the opposite side of the color wheel. Split complementary color harmonies are great for beginners because they create nice contrast and give you more colors to work with. It's usually good for using two base colors and an accent color.

Analogous

Analogous color harmonies typically consist of one base color and two colors on each side of that color on the color wheel. These color palettes are eye-catching, and usually feel very harmonious and soothing.

Triadic

Triadic color harmonies consist of three colors evenly spaced on the color wheel. Using those colors together gives bold contrast but is a little less intense than regular complementary colors.

When using these color palettes, it's best to use one of the colors as your primary color and the other two as accent colors.

Tetradic

Tetradic color harmonies consist of four colors evenly spaced on the color wheel. Tetradic color harmonies are also called double-complementary color harmonies because they consist of two pairs of complementary colors.

These color palettes are considered the boldest color combinations and should be used carefully as they are hard to balance. With these color palettes, one color is recommended as your base color and the others as accents.

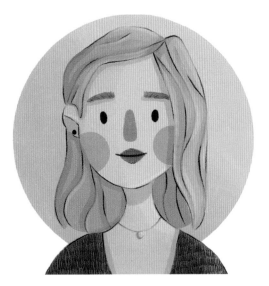
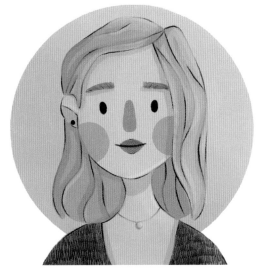

WHAT IS SATURATION?

Simply put, saturation is the intensity of a color.

Color can either be saturated, which is bright and vivid, or desaturated, which is dull and washed out. The more desaturated a color, the closer it is to being grayscale.

In the example above, you'll see that the version of the portrait on the left has bright and vivid colors and is intense! It has a high saturation. The version on the right is duller, and the colors are less vivid. So, it's desaturated.

WHAT IS DARKNESS AND BRIGHTNESS?

Brightness refers to how light and bright your color is, whereas darkness refers to how dark it is. Generally this is only adjusted by one brightness slider.

Color can be bright, or it can be dark. In the example I've chosen a color (center) and adjusted the brightness lower (on the left) and higher (on the right).

Although the two colors in this example have the same hue, they have different saturation and brightness levels. It shows the difference in feeling you can convey by adjusting the saturation and brightness of a color.

For example, when using bright colors with low saturation, it gives a soft feeling. Darker colors with high saturation provide a hard and strong feeling. Low contrast and low saturation give a calm feeling, while high contrast and high saturation give an active feeling.

TINTS, TONES AND SHADES

There are other ways to adjust the look of a color: tints, tones and shades.

- Tints are created by adding white to your color.

- Tones are creating by adding gray to your color.

- Shades are created by adding black to your color.

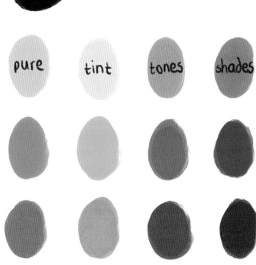

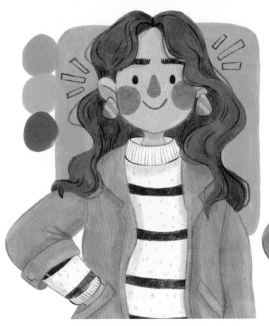
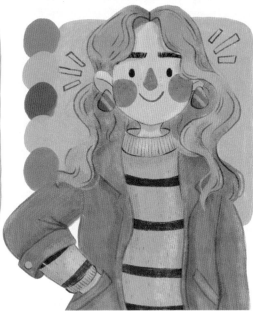

KEEPING IT SIMPLE

When working with color, especially as a beginner, it is critical to remember that LESS IS MORE. I've seen this concept likened to seasoning a meal while cooking. With digital art, you have every color possible available at your fingertips. So, in the same way that you shouldn't use EVERY spice when cooking a dish, you shouldn't use every color in one painting.

Keeping it simple will go a long way toward making your illustrations look more pleasing and harmonious.

In this example you'll see that a simpler color palette is usually more eye-catching and harmonious.

A great little tip to help you is the 60-30-10 design "rule."

- 60 percent of your illustration should be your primary color.
- 30 percent should be neutral.
- 10 percent should be an accent color.

And finally, the best way to check if your illustration looks good is to check what it looks like in grayscale. Contrast is essential, so if your drawing looks good in grayscale, it will work in color! This is because every color has a specific value, and when the colors you use are all too similar in value, the image will look flat and muddy in grayscale. When your colors have different, contrasting values, the image will be clearer and look good in grayscale.

Highlights and Shadows

Highlights are the light areas on an object on your canvas. These are the areas where light hits. The places where light doesn't hit are the shadows.

Highlights and shadows are an incredibly important part of illustration. Using them brings depth and dimension to an otherwise flat image. They can also create a specific atmosphere in your illustration, like dark and gloomy or bright and happy.

This topic can get incredibly complex, but it's best to start simple. As you gain experience, you will naturally be able to recognize light and shadows more easily in real life and then apply them to your art.

A good way to practice is to take any of the photos on your camera roll and try to identify darker and lighter areas, like I've done with this photo of my puppy, Luke (RIP).

HOW TO VISUALIZE A LIGHT SOURCE

Unlike in real life, no actual "light" hits any objects on your digital canvas, so it's helpful to imagine a light shining from a specific point. I sometimes even like to draw a light and its rays to help visualize it easier.

I drew a simple circle in the example to imagine a light. If a light shone from the top left corner of the canvas, the object would have highlights in that area that faces the light and shadows at the opposite end.

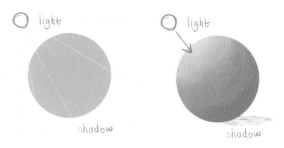

A ball is a simple shape, though, and the highlights and shadows are very straightforward. With something a bit more complicated, like a face, there are hills and valleys to visualize.

So, take a look at this simple portrait. Visualize a light source in the upper left corner.

Now, imagine the areas on her body that stick out more than other areas.

Then imagine the areas where the least amount of light will hit.

The easiest way to create highlights and shadows is to use Blending modes: Multiply for shadows and Overlay for highlights.

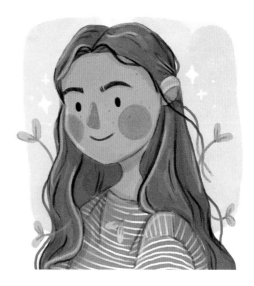

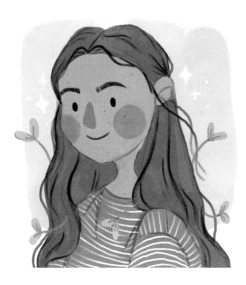
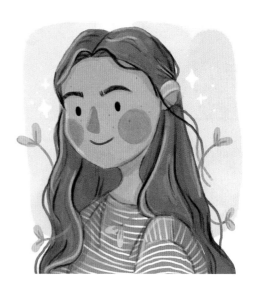

You can use a light buttery yellow for highlights and blue or violet color for shadows. It will look quite harsh, but you only need to lower the opacity at the end.

So, now look at the side-by-side of this portrait with and without highlights and shadows.

In this example, the original image looks quite flat and plain, but with the addition of simple highlights and shadows, it now has depth and is much more eye-catching.

The same concept applies to drawing whole bodies, animals and objects. Imagine a light source and determine which parts stick out and which don't!

Composition and Perspective

COMPOSITION

Composition is the way you arrange the elements of an illustration. It's how you lay things out on the canvas. Although there's no single "best" formula for composition, some helpful guidelines exist to create pleasing compositions.

Before you begin, in your mind, create a clear and strong focal point for your illustration. Think about the most important part and how you can make it stand out.

The Rules of Thirds

The Rule of Thirds is considered the "golden" rule and the only one we will discuss in this book since it's a great trick to always keep in the back of your head.

Imagine a 3 x 3 grid placed over your canvas, and then use the lines and cross-points to help place the focal points of your illustration. When you use these lines and points of a 3 x 3 grid to arrange elements on your canvas, your illustration will generally look more pleasing and dynamic.

Procreate has a handy grid function that can help you initially! In the Actions menu, under the Canvas tab, you'll find the Drawing Guide. Toggle it on, and then tap "Edit Drawing Guide."

There are two points visible on the grid. The green point will tilt your grid, and the blue point moves the grid.

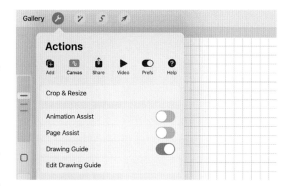

Play around with the grid size, and move the point on the grid until you've got a 3 x 3 grid. For my canvas [3000 x 3000px], I moved the point down and left, and the grid size to 1000px. That can help you lay things out as you sketch!

The Rule of Thirds is a great way to help guide someone's eye around your painting, especially in combination with other techniques.

In this example, you can see that I used the Rule of Thirds. My horizon sits mostly close to the lower third. Clouds are mostly in the middle third. And then I've placed my focal points (the little cottage and moon) on the cross point of the lines.

Always keep it simple when you're starting out. Too many focal points and visual clutter in your illustration can create confusion, so finding a good balance is essential.

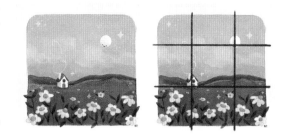

Remember to flip your canvas horizontally periodically! It will accentuate any compositional errors or wonkiness, and you can figure out where to adjust things.

PERSPECTIVE

Perspective is a way to create a three-dimensional feeling on a two-dimensional canvas. Procreate has a fun tool for making perspective drawings easier.

When you turn on the Drawing Guide, tap "Edit Drawing Guide" and choose "Perspective."

Since perspective drawing is a highly complex topic, we'll only look at one-point perspective in this book. It is the easiest one for beginners.

With one-point perspective, you need a horizon and a vanishing point. Your horizon can be where the sky meets the land (or water!) or where the wall meets the floor when indoors.

So, let's look at how you could draw a simple room using a horizon and a vanishing point.

I. Open the "Actions" menu, and navigate to the "Canvas" section. Turn on the Drawing Guide and then tap "Edit Drawing Guide." Choose "Perspective" and tap on your canvas to add a single point. Adjust it to the center of the canvas.

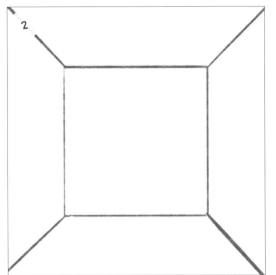

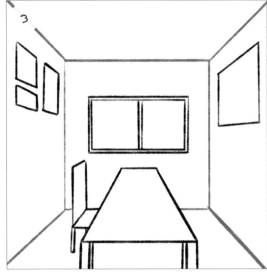

2. Now start sketching. Begin with the room. Draw the floor and walls. The floor is your horizon.

3. Now add a window, picture frames, a table and a chair.

4. Finally, lower the opacity and sketch your room again, adding in some extra details.

5. This room used a center vanishing point, but you can move the vanishing point all over the canvas to create a completely different perspective and effect.

Lines and Textures

LINES

In digital art, you can do lined or lineless art. With lined art, your illustrations will have clear outlines; with lineless art, it won't! It's really just about your personal preference. I prefer a hybrid lined/lineless style where I only add line art here and there, usually to create separation and contrast between different elements.

Line Weight

Line weight is a critical thing to remember when drawing line art. This is the heaviness or thickness of the lines you draw.

When drawing line art, it's good to vary the line weight. Look at the example below to see the difference it makes when drawing line art with the same line weight and how it looks when you make some natural variations.

For example, with digital art programs, you can adjust the size of a pencil brush way smaller and way larger than a real pencil could ever be. So, if you're digitally drawing super-thin pencil lines that are impossible to recreate with a real pencil, your art will have a definitive "digital" look.

If you want your digital illustrations to look more traditional or analog, ask yourself: Can I do what I'm doing with real pens or pencils?

This specifically goes for drawing lines super thin or too consistently (using perfectly straight lines made with quick shapes and lines).

My method for varying line weight is drawing heavier lines when moving my pencil down and lighter lines when drawing up. It's similar to the technique used in hand lettering! Then, I ensure that the main outlines are heavier and thicker and that other smaller or less important details and textures are lighter.

Something else to keep in mind for creating natural-looking digital art is to consider if your line weight is possible to recreate with traditional tools.

freehand line tool

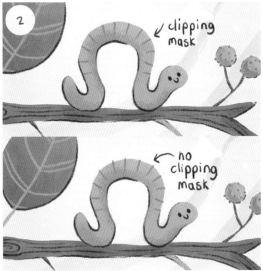

TEXTURE

There are many ways to create beautiful textures with digital art, and digital artists often spend a lot of time figuring out how to make their art look less digital and more natural, like traditional art.

Here are some tips for creating more texture in your digital work:

1. Use off-white for your canvas color. Pure white doesn't exist in nature. Your illustrations will look much warmer and more appealing when you don't use white.

2. Don't overdo Clipping Masks and Alpha Lock! Imperfections are important.

3. Color manually instead of using "color fill" for flat colors. This creates gorgeous textures!

Color fill (left) vs. colored manually (right)

4

5

6A

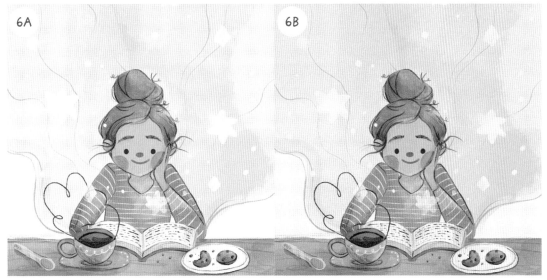

6B

4. Vary color slightly on flat colors to give depth! Add some darker and lighter areas. This gives the same effect as not perfectly mixing actual paint. It provides a subtle but beautiful color variation! Some Procreate brushes, like the Larapuna brush we'll use in the Happy Puppy Portrait on page 120 do this automatically.

5. Add scribbles and specks, and paint splashes in strategic areas.

6. Use the noise tool or paper overlays for an all-over texture.

7

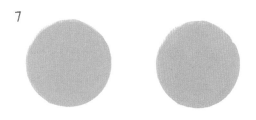

7. To add a paper overlay, all you need is an image with a paper texture. You can download free paper textures anywhere online, or even scan a paper yourself! Then, place it at the very top of your layers, set the layer to Multiply, and adjust the opacity to your personal preference.

Drawing Tips

Before we jump into all the actual drawing projects, I want to discuss my best tips for getting started and improving your digital drawing skills.

At the end of the day, it doesn't matter whether you're drawing with pen or paper or using a fancy iPad and Procreate. It all comes down to knowing and practicing basic drawing skills.

Everything you look at can be broken down into shapes, and those shapes have a particular relationship with each other, or connect to each other in a specific way. Light shines on these shapes, and it creates shadows, which give it depth, dimension and texture.

Let's look at this illustration of a camera.

This illustration is essentially an arrangement of rectangles, squares and wavy lines. An imagined light shines on these shapes and creates the illusion of layers and depth. It turns an arrangement of 2D shapes into a 3D object that you can recognize.

The best way to train your eyes to start noticing these simple shapes and the relationships between shapes, light and shadows in everyday objects, is to practice drawing as close to life as possible. This means drawing what you see with your eyes or referencing actual photographs of objects or people. Don't try to draw from your imagination!

You can search for reference images on Pinterest or Instagram. You can take your iPad with you wherever you go, and sketch everything

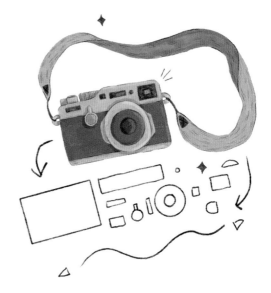

you see around you: your coffee cup, a chair across the room, your little potted succulent, the pillow on the couch or the tree outside your window. There's always an opportunity to practice your drawing skills. If you do this for just 5 minutes a day, you won't believe how fast you improve!

Couple that with knowing Procreate basics and getting familiar with them, and you'll soon be making your own amazing digital art! So, with all of that in mind, grab your iPad and Apple Pencil, and let's start drawing!

Faces

How to Draw Eye-Catching Portraits

Faces are absolutely one of the most fun things to draw! PLUS, they're very easy to draw when you understand basic facial proportions. Human anatomy is a fundamental skill that every artist should know. Even when drawing in a simple style, it makes all the difference knowing and drawing the correct proportions!

Of course, sometimes, you can deliberately exaggerate facial features to intensify your message or the feeling you're trying to convey. Doing this with an underlying understanding and proportional "correctness" works better and doesn't just make things feel off.

These examples show the average adult proportions and average baby or young child proportions.

A big reason babies and kids are so cute is their proportions, which are totally different from adult proportions.

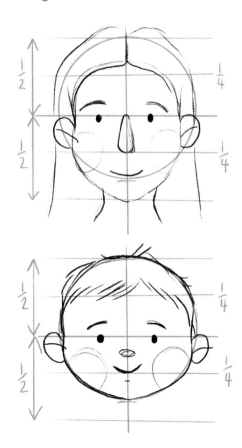

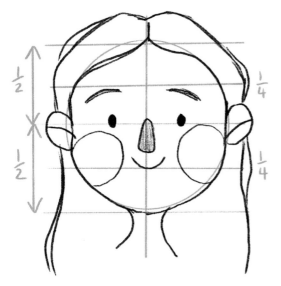

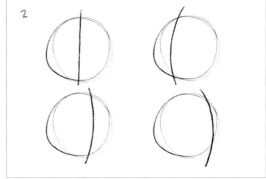

When drawing in a stylized way, you'll often find that "cute" character art tends to lean more toward baby proportions. So, if you look at the way I stylize faces, you'll notice that for drawing adults, I use something between adult and squished baby proportions to give a much cuter look.

Remember, although correct proportions make things look right when drawing, you can do whatever you want! In art, rules are meant to be broken. But truly understanding the rules can help you break them in deliberate ways and for reasons that make sense.

So, let's sketch faces!

1. Always start with a circle.

2. Then draw a curved vertical line across your circle. This is to help you visualize the direction in which the face will be angled.

TIP: Keep things loose and rough when you sketch. Draw larger sweeping motions with your whole arm and loose wrist, not small stiff lines with a locked wrist. Use light pressure and draw soft lines. Throw perfection out the window!

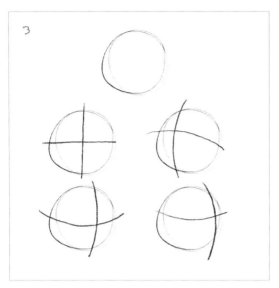

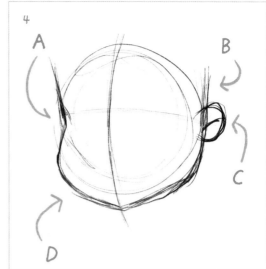

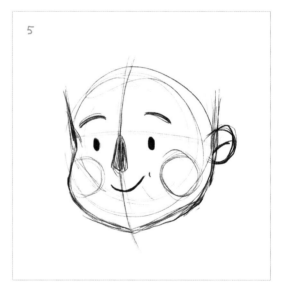

3. Draw a curved horizontal line to help you visualize the vertical angle of the face (whether it's facing up or down, or somewhere in between).

4. Draw the shape of the face. You can choose any of your guidelines drawn in the first step. I decided on a simple three-quarters view.

A. Eyes go on the horizontal line. Faces "dent" in this area because of low fat content, and your cheeks puff out because they have a higher fat content.

B. The other side of the face is a little more angular because your jawline will be more visible.

C. Ears also align with the center line. The tops of our ears usually align with the tops of our eyes.

D. Draw a jawline and chin at or below the circle guideline. This depends on who or what you're drawing. Babies have smaller chins, while men have larger, more angular jawlines and chins. Women will have smaller and more curved jawlines and chins. Again, these are not hard rules.

5. Finally, draw the facial features. The top of the nose should be at the center where your two guidelines cross. Eyes should be drawn at or just below the horizontal line. Then, add a happy smile!

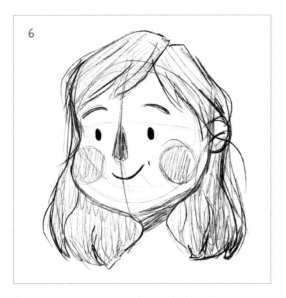

6. Imagine the top of the circle to be the top of the forehead. How high the hair puffs up depends on the hair type or hairstyle.

When facing forwards, center the neck to the center line. When your face is angled, angle the channel from the center line to whichever way they face.

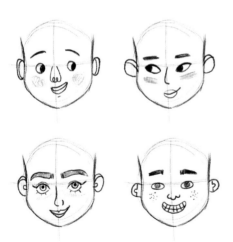

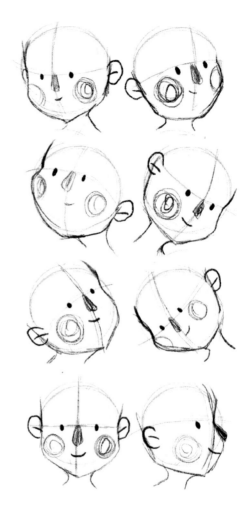

Here are some examples of a face from different angles.

There are also endless ways to style facial features. The best way to figure out what you like is to take inspiration from other artists and try different things until you find the way you like best, and apply it in your own unique way.

Tell a Story with Facial Expressions and Emotions

Human faces are incredibly expressive, and with simple techniques, you can convey any emotion you can think of!

There are seven primary facial expressions that all humans make. These can be recognized by anyone, regardless of their culture. These are:

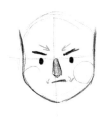
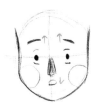

- **Anger:** Think of sharp, downturned facial features.
- **Fear:** Eyebrows and eyes are pulled up, and the mouth is stretched open.
- **Disgust:** Facial features are squished toward the center of the face.
- **Happiness:** Eyes tighten, and the corners of the eyes, cheeks and lips are raised.
- **Sadness:** Inner eyebrows are raised, and other features pull down.
- **Surprise:** Everything pulls up and out, and the mouth hangs open.
- **Contempt:** This is a one-sided expression with neutral eyes and the mouth pulled back on one side.

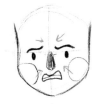
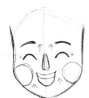

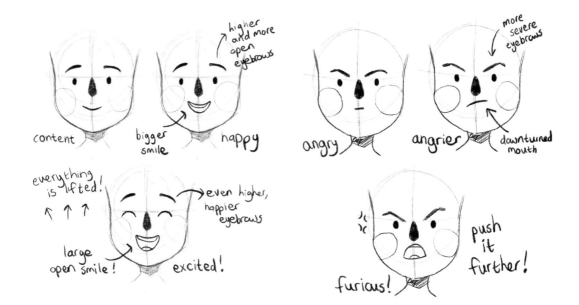

content

bigger smile

higher and more open eyebrows

happy

angry

more severe eyebrows

angrier

downturned mouth

everything is lifted!

even higher, happier eyebrows

large open smile!

excited!

furious!

push it further!

TIP: When you draw facial expressions, start simple and then EXAGGERATE! To convey emotion through a drawing, you must push it further and ensure the expression you're drawing is crystal clear to the viewer.

Of course, even though there are just seven main expressions, countless others derive from the main ones. The opposite page features some different facial expressions to get you started.

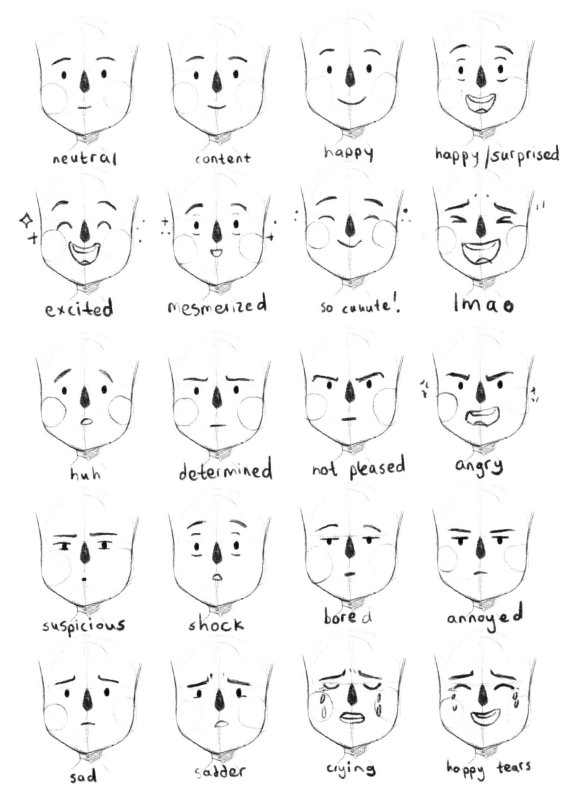

Project: Simple and Cute Portrait

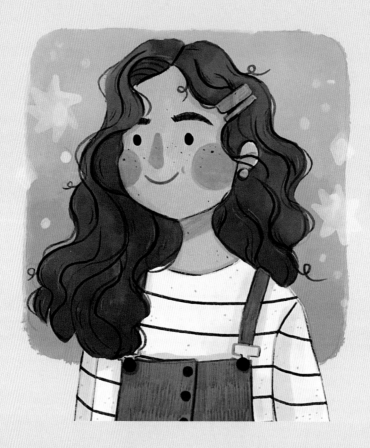

In this step-by-step project, I will show you the process of drawing a simple portrait illustration. We will consider what we've learned about faces (see page 59) to draw a cute portrait of a girl with long, wavy, brown hair, wearing dungarees! First, we sketch, then color and finally, we do all the final touches to create a complete illustration!

BRUSHES

- 6B Pencil (in the Sketching tab)
- Tamar brush (in the Painting tab)

TOOLS AND TECHNIQUES

- Alpha Lock and Clipping Masks
- Vivid Light and Multiply blend modes
- Noise
- Liquify

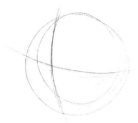

SKETCH AND DRAW

I. On a new square canvas (3000 x 3000px), draw a rough circle with the 6B pencil (size 20–30%) in a dark gray for sketching.

2. Draw a curved cross to orient your face. The vertical line is for orienting the center of the facial features, meaning the direction the face is looking or angled: left, right or center. The horizontal line is the eye and ear line. Is the face angled upward or downward? So, for this portrait, our girl's head faces more to our left, and her head is tilted slightly upward. She's got a quiet confidence about her!

3. Draw the shape of the face using the circle and cross as your guide. Since she is facing in a specific direction, we will see more of her round cheek on that side. The eye line "dents" in because there isn't a lot of fat in this part of human faces, whereas the fat in our cheeks is more visible so that part puffs out. On the other side of her face, we see the more angular shape of her jawline!

3

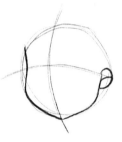

4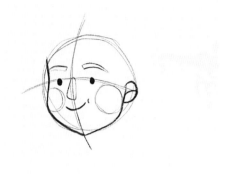

5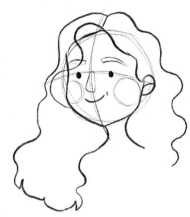

6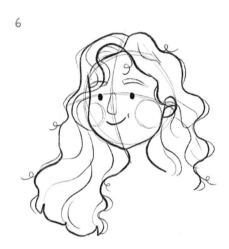

7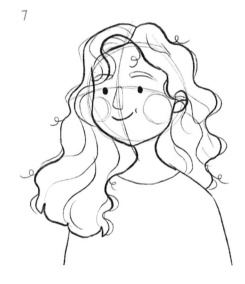

4. Draw her facial features with her eyes and ears lining up with the horizontal line. Her nose is centered on the cross.

5. Draw the rough shape/outline of her hair. The top of our original circle is her hairline, and her fluffy wavy hair determines how high it poofs up from her hairline.

6. Add some sections and strands to the hair and some flyaways! This really gives a more natural and looser look to the hair.

7. Add a basic body shape to our girl.

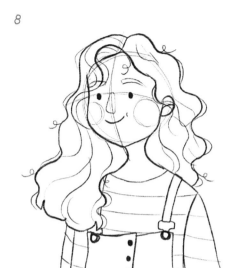

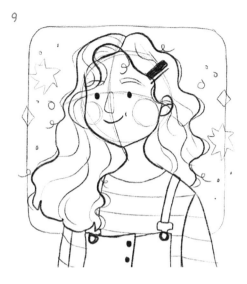

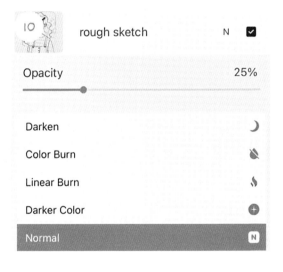

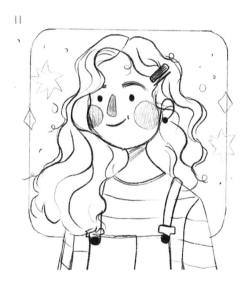

8. Draw her outfit. She's wearing a stripy T-shirt under dungarees.

9. Add a rounded square background, hair accessories and a few sparkles to finish.

10. Lower the opacity of the rough sketch layer to 25%, and then tap the + button to create a new layer above the rough sketch layer.

REFINE

11. You will now refine your rough sketch on this new layer. That means you are redrawing the sketch, making it look cleaner and neater! We're only drawing the outlines—everything we want in the final illustration. So, we can leave out the guidelines we drew in the beginning.

12

14A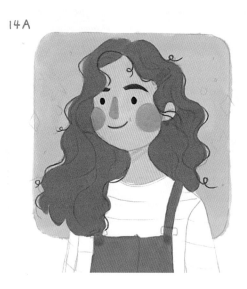

14B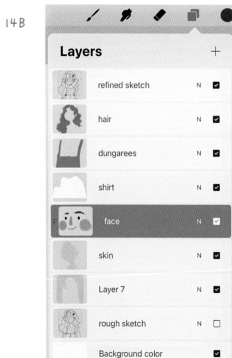

COLOR

12. Now that you have a neat sketch, it's time to add color! Coloring is one of the most fun parts of digital illustration but also one of the parts that can be the most difficult. Choosing the correct colors can make or break an illustration with digital art! When you have every color available at the touch of a fingertip, it can get overwhelming. That's why it's best to stick to two or three colors per illustration, especially when you're just starting. For this simple portrait, you will be using these colors (and variations of them!).

NOTE: I usually default to a warm, creamy color for my canvas. It seems insignificant, but it goes a long way to making your digital drawing feel warmer and more natural. This is because pure white doesn't really exist in nature.

13. Start by turning off the rough sketch layer. Then set the refined sketch's opacity to 25%. We will add all the color layers underneath our sketch. That way, the sketch stays visible while we work.

14. With the Tamar brush (sized 5–10%), lay down the flat (or base) colors for the illustration. Place each element or different color on its own layer. (The Tamar brush is a pretty painterly brush that varies its opacity with the pressure of the Apple Pen on the screen.) I usually start with the skin layer, followed by the hair, clothing, accessories and other details. Don't worry if your illustration looks a little flat at this point! Trust the process.

15

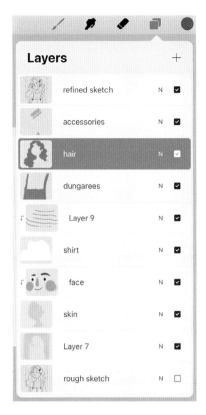

15. We will use clipping masks for her face and shirt details. As you learned in Clipping Masks (page 35), anything we draw on a clipping mask layer cannot cross the boundary of whatever is drawn on the layer below.

Now you can create a new layer above the skin layer, tap on it and choose "Clipping Mask." That way, her facial features will only be visible on the skin layer below. So, you don't need to be too precise when drawing her cheeks!

Do the same thing above the shirt layer. Create a new layer set as a clipping mask. The stripes on the T-shirt will now only be visible on the white of the T-shirt below.

16A

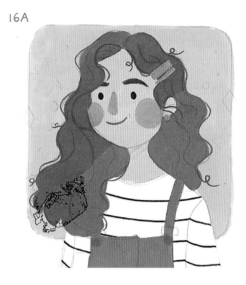

16B

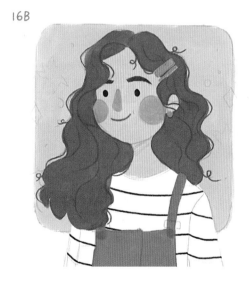

16. The above image is a good example of the benefits of using layers. I decided that the character should have brown rather than red hair, and the color can be easily changed by turning Alpha Lock on for the hair layer and drawing over that part in the new color.

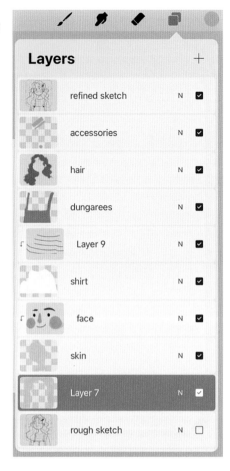

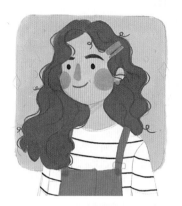

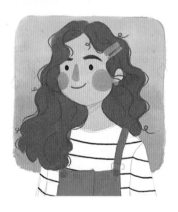

17. Once you have all the flat colors and are happy with how things look, continue to the next part: giving the illustration more depth and texture. Turn on Alpha Lock for all the flat color layers by swiping right over the layer with two fingers. You can tell when Alpha Lock is on by the checkered pattern that appears in the layer preview's background. This ensures you can't color "outside of the lines" of anything drawn on that layer. It is one of the best ways to add textures, highlights and shadows to our flat colors. It's also my favorite way to create a pretty, painterly effect. Start at the bottom layer, in this case, the green square background, and work your way up.

18. Use the eyedropper tool to pick the base color you will be drawing on top of. (Long press on your canvas to get the color picker.) Then, using the Classic Color Picker wheel to vary the brightness and saturation of the color, lightly paint over the flat color to give it some dimension.

19

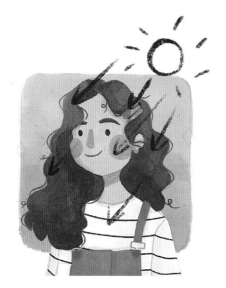

20A

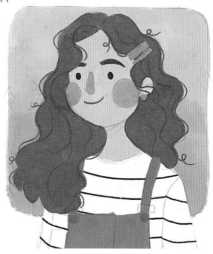

20B

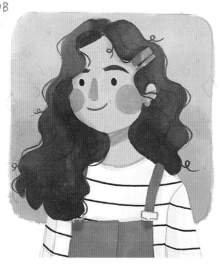

19. I also like to keep a light source in mind when creating textures this way. That way, it's easy to paint darker textures and shadows everywhere you imagine a shadow falls. Paint lighter textures on parts that "stick out" or sit closer to your imagined light source.

20. Repeat this process with every layer that contains a flat color. You can see the comparison of the flat base colors and how it looks with texture added below.

A great thing about using Alpha Lock for this process is that you can oversize your brush (in this case, the Tamar brush to 20–30%) and get some great big textures!

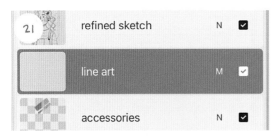

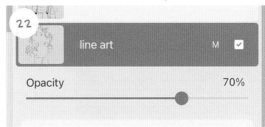

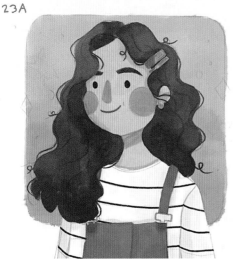

23A

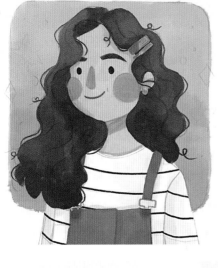

23B

21. Once you've added these textures and color variations to all the flat color layers, create a new line art layer below the refined sketch layer. Then set the blend mode to Multiply.

22. Slightly lower the opacity of the line art layer to lessen the intensity to somewhere around 70%. Return to the 6B pencil to add more definition and contrast to the portrait.

23. Because you're using a layer set to multiply the line art, it "multiplies" and blends the base layer's color and Multiply layer, creating a darker color. So, for example, when drawing lines and strands on her hair, color-pick the brown base of her hair color. Now, drawing over her hair on the Multiply line art layer creates a darker brown that works perfectly with the base color.

Do that with every section and color. When drawing lines for her dungarees, color-pick the green. When drawing lines for her golden accessories, color-pick that yellow. Having colored vs. black line art gives the illustration a much softer, more harmonious look.

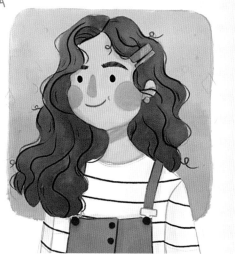

24A

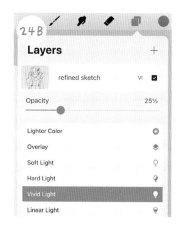

24B

Layers +

refined sketch VI ☑

Opacity 25%

Lighter Color ⊕
Overlay ≋
Soft Light ♀
Hard Light ♀
Vivid Light ♀
Linear Light ♀

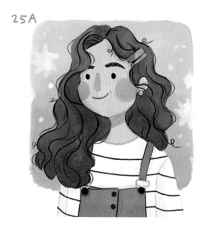

25A

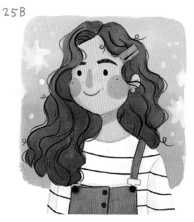

25B

24. At this point, I usually set the blend mode for my refined sketch layer to Vivid Light. There's no reason for this other than liking how the effect looks. Keeping the sketch layer visible in the final illustration also helps give a more textured and natural look to the final illustration.

25. Add subtle sparkles using a light yellow and the Tamar brush. And then continue with the final touches! Above all the layers, but still below our sketch layer, create a new layer for extra details and textures. On this layer, go over the entire drawing using the 6B pencil, adding some dots and scribbles here and there.

26. Now, let's add some freckles. Above the face layer, add another new clipping mask to the skin layer called "freckles." Use the 6B pencil and a warm brown color to add freckles to her face.

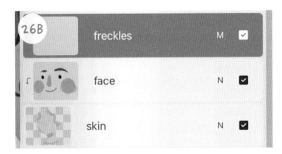

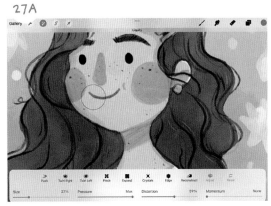

27A

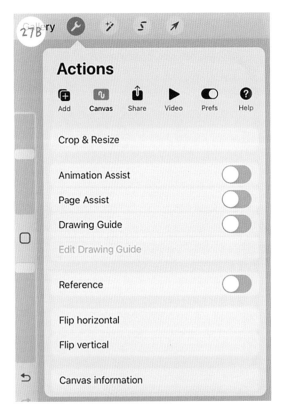

Actions

Add Canvas Share Video Prefs Help

Crop & Resize

Animation Assist

Page Assist

Drawing Guide

Edit Drawing Guide

Reference

Flip horizontal

Flip vertical

Canvas information

27. Toward the end of the drawing process, you can use the Liquify tool to adjust the shape of her smile or anything else that might look a little wonky. Only do this if it's needed! (It's in the Adjustments drop-down menu.) An excellent way to check for wonkiness is to periodically flip your canvas. You can do this by going to the Actions menu, under the Canvas section, and tapping "Flip horizontal" or "Flip vertical."

28

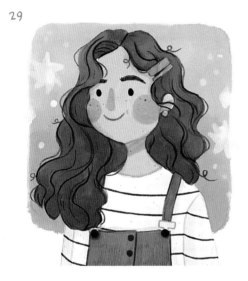

29

Layers +

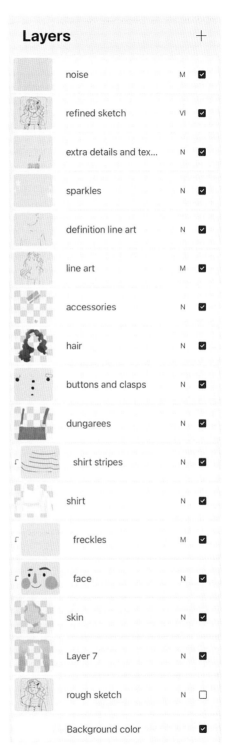

	noise	M	☑
	refined sketch	VI	☑
	extra details and tex...	N	☑
	sparkles	N	☑
	definition line art	N	☑
	line art	M	☑
	accessories	N	☑
	hair	N	☑
	buttons and clasps	N	☑
	dungarees	N	☑
	shirt stripes	N	☑
	shirt	N	☑
	freckles	M	☑
	face	N	☑
	skin	N	☑
	Layer 7	N	☑
	rough sketch	N	☐
	Background color		☑

Final layer arrangement

28. Now, create a new layer on top of all the other layers and set it to Multiply. Under the adjustments button, add noise to 6%. (You can adjust the percentage by dragging your finger left or right over the screen.) The "noise" will be the color that is currently selected. I generally choose dark gray for noise. Adding noise creates a subtle all-over texture that gives the illustration a papery feel.

29. Finally, zoom out and give your illustration an overall inspection. The final thing it needs is more contrasting or defining lines to her face, shirt and accessories. Create a final new layer above the original line-art layer, and use the 6B pencil in a dark gray color to add definition.

Bodies

How to Draw Dynamic Full-Body Poses

Figure drawing is one of the most basic fundamental skills every artist should know. So, in this chapter, I will share some tips and tricks for drawing bodies and poses that will help you create more believable and dynamic characters for your illustrations. A proper foundation will make things look right, even with a simple drawing style! We'll also take a quick look at body language basics before drawing a full-body character.

Let's start with basic body proportions:

Babies and toddlers are about three to four heads tall.

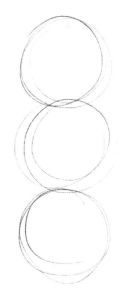
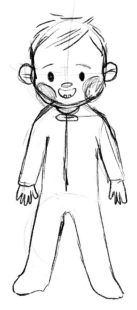

Older kids and tweens are about five heads tall.

Adults are generally about seven heads tall. If you want your person to look VERY tall, you can push it to eight heads!

Here are some simple tips and tricks to help you remember important proportions when drawing bodies.

- The middle point of the body is approximately at the hips.
- Your wrist lines up with the center of your hips too!
- When adult arms hang loosely to the sides, their hands reach mid-thigh.
- An adult's hand is usually the size of an adult's face. (Kid and baby hands are smaller!)
- When you touch your left shoulder with your left hand, or right shoulder with your right hand, your fingers typically reach the middle of your shoulder.
- An adult foot is the same length as the distance between the elbow and wrist of an outstretched arm.
- The distance between the elbow and wrist on a bent arm is the size of a hand.
- When you sit on your heels, your knees reach up to your chest.

These are all average proportions, and there are always variations! So, none of these measurements are set in stone, and you can stylize human bodies however you like. I tend to draw adults about five to six heads tall because I am trying to achieve a "cute" look. We think babies are so cute because of their large heads, big eyes, chubby cheeks, cute button noses and small mouths. In other words, it's all because of their proportions!

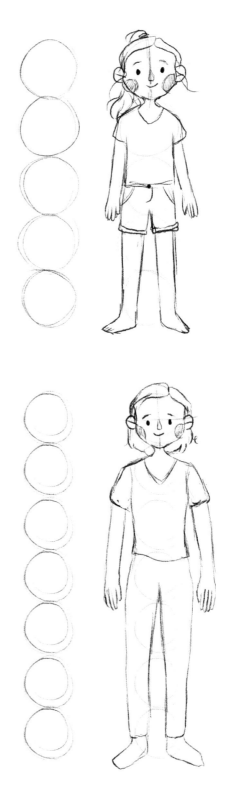

Create Characters Using Stick Figures

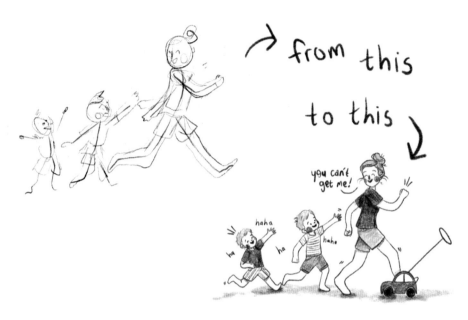

The easiest way to quickly lay out full-body character is, believe it or not, with stick figures! I usually roughly lay out more complex illustrations using stick figures first.

If you think about a stick figure, you usually imagine something that looks like this: A circle for a head, a stick for a body, two sticks for legs and two sticks for arms. That's great, but a simple tweak will make your stick figures much more usable! Give your stick figures a more natural human shape by adding a line for the shoulders and hips.

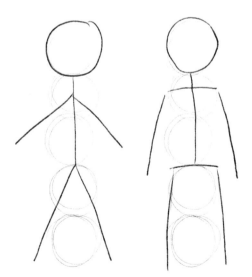

You can even box the torso if that helps you visualize it better.

Drawing stick figures this way makes it so much easier to fill out a body on top of this simple guide or "skeleton," because they already have a mostly correct shape and occupy a more accurate amount of space on the canvas.

Drawing a bunch of randomly posed stick figures, and then roughly drawing over them, is a great way to practice or warm up before illustrating. The point is to stay rough and loose. Don't worry about drawing a perfect face or perfect hands and feet. Just focus on getting the main body proportions correct.

A lot of times, you want to zoom in and get a hand just right, or draw a super cute face, or add too much detail to the hair. But I advise keeping your canvas zoomed out and forget about details. Draw big shapes and focus on the proportions. Here's how I roughly filled out my stick figures!

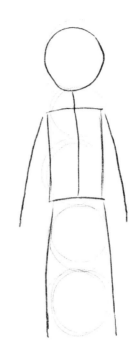

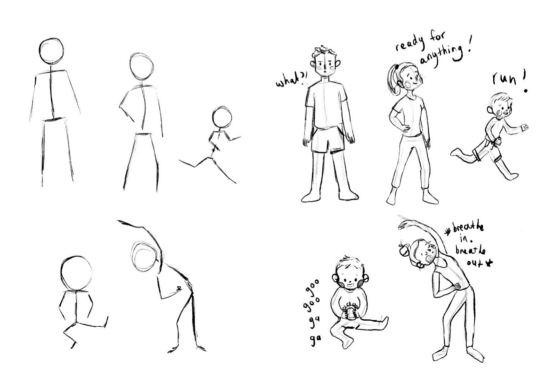

A Quick Overview of Body Language

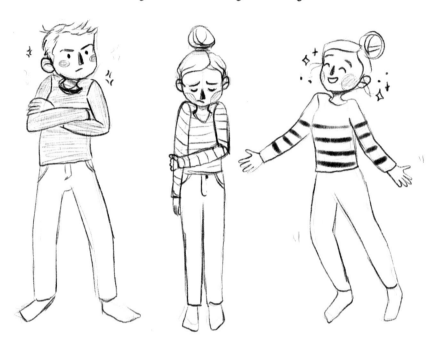

Body language is various physical signals from our bodies communicating emotions or intentions. There are facial expressions as well as gestures. Body language is usually done subconsciously and is a massive part of human communication!

As with the primary facial expressions, our bodies also convey emotion. So, let's look at some of the main emotions again and how they are communicated through our bodies and gestures.

- **Anger:** When angry, people usually try to square off, trying to appear more intimidating. This can include moving arms away from the torso in an aggressive way. Crossing your arms can also indicate anger or aggressiveness. There is also tension in your hands, like clenched fists or finger pointing. When portraying anger, it's all about the tension.

- **Sadness:** When sad, your body will usually be hunched and your head lowered, as if trying to curl inward and shut down.

- **Happiness:** Happy bodies are relaxed with the shoulders, arms and palms open!

Project: Little Ballerina

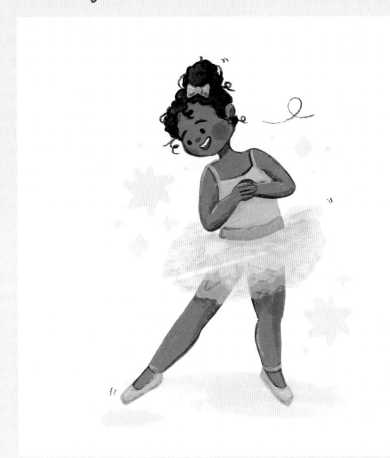

Let's take what we've learned about body proportions and draw a cute little ballerina to practice drawing whole bodies! As you can see in this project, I usually use no more than two to three brushes per illustration and normally stick to a very limited color palette. Limiting yourself this way is helpful because, with so many options available, it's way too easy to overthink and overdo things. When you limit your options, you can focus on your drawing technique and make your ballerina friend come to life!

BRUSHES

- 6B Pencil (in the Sketching tab)
- Oberon brush (in the Drawing section)

TOOLS AND TECHNIQUES

- Opacity
- Multiply, Overlay and Vivid Light blend modes
- Noise

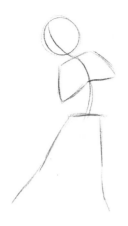

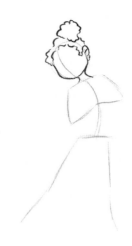

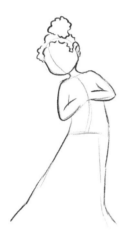

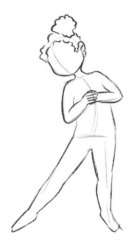

SKETCH AND DRAW

1. Using the 6B pencil at size 20–30%, draw a simple stick figure. Imagine a little girl bending down slightly to admire her ballet outfit. Draw your stick figure with child proportions—her body should be about five heads tall.

2. Lower the opacity of the stick figure and roughly fill out a body over the top. Start with a rough head and neck.

3. Add her arms, body and legs. You're basically just fleshing out your stick figure, giving it shape and curves. Don't worry about details. Just round things out and focus on body proportions.

4. When you're happy with how things look, fill out the rest of her body.

5

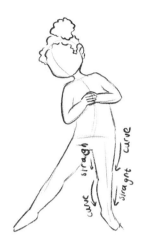

6

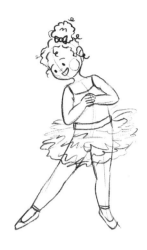

5. Pay attention to how her legs curve.

ADD DETAILS

6. Now add the rest of the details. Keep her facial features simple. Align her nose to the center line, with a happy smile underneath. Add eyes that line up with the top of her nose and simple eyebrows. (Check out How to Draw Eye-Catching Portraits on page 59 for more in-depth details on drawing faces.) Also draw a simple ballerina outfit.

7. Finish the sketch with a few sparkles and extra details.

7

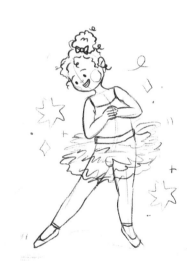

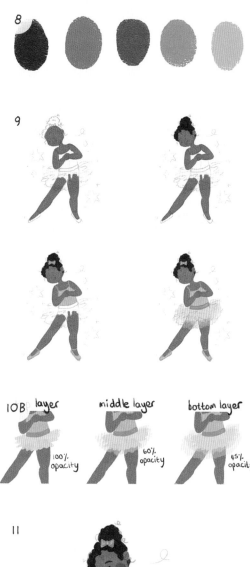

8

9

10A

Layers			+
sketch		N	☑
tutu elastic		N	☑
tutu top later		N	☑
tutu middle layer		N	☑
tutu bottom layer		N	☑
shirt, shoes, hair bow		N	☑
hair		N	☑
skin		N	☑

10B layer middle layer bottom layer

100% opacity 60% opacity 45% opacity

11

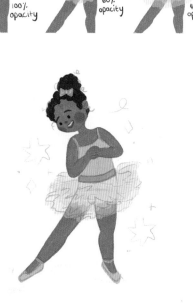

COLOR

8. We're going to use this very simple color palette. And then, we're going to use the Oberon brush from the Drawing section, sizing it anywhere between 15% and 30%, depending on the size of whatever you're coloring. You'll be constantly adjusting the brush during the coloring process.

Lower the opacity of your sketch layer to 30%. Create a new layer below your sketch to start painting the base colors of her skin. Create a new layer above the skin layer.

9. Now paint the base color of her hair, using circular motions to create extra texture. On another new layer, paint her outfit and accessories, making each section or part its own layer.

10. To create a transparent effect for her tutu, separate the skirt into three layers, turning down the opacity on two of them.

11. Now create a new layer above the skin layer but below the hair layer. Use the 6B pencil to add her facial features and the Oberon brush to add her cheeks.

12A

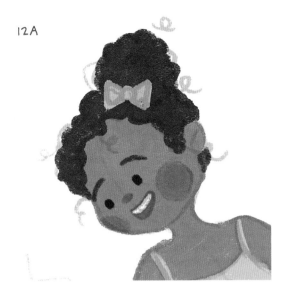

12B

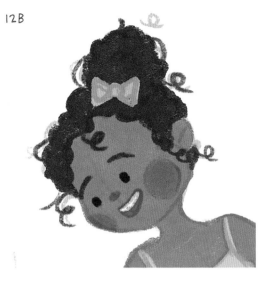

13

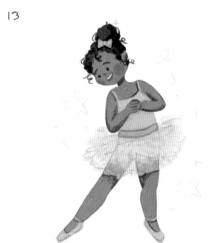

14

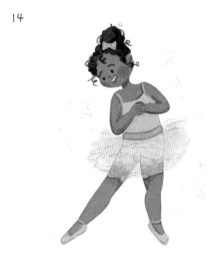

12. Go back to the hair layer and use the 6B pencil to add flyaways and loose curls to give the hair more dimension.

13. Create a new layer above all the base color layers but below the sketch. Set the blend mode of this layer to Multiply. Now use the Oberon brush to paint shadows over the entire illustration. Use the eyedropper tool to pick the color of whichever base color you'll be drawing over.

14. Lower the opacity of your shadows layer to 65% to make them a little more subtle.

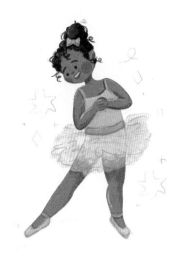

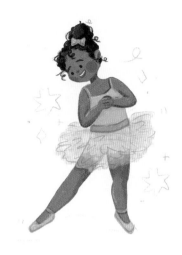

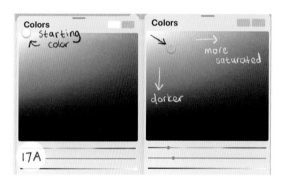

15. Create another layer above the shadows layer and set the blend mode to Overlay. Pick a light buttery yellow and use the Oberon brush to draw a few highlights while trying to visualize a light source coming from the top left of the illustration. A general rule of thumb is to add highlights on the part closest to the light source as well as sections that might stick out more than others. (See Highlights and Shadows, page 49.) This means that the highlights will hit the top left of her head, her shoulders, the fronts of her arms and hands and a little bit on her feet and legs.

16. After you're happy with your highlights, lower the opacity of this layer to 70%.

17. On a new layer at the very bottom, use the eyedropper tool to pick the creamy background color. Go to the Classic Color Picker and make the colors slightly darker and more saturated.

To do this, move the dot to the left for more saturation, and down to go darker. Then lightly paint a shadow underneath your little ballerina.

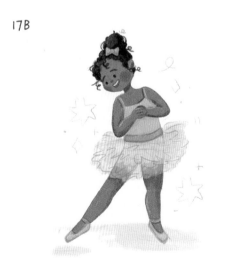

18A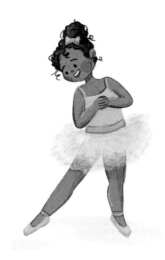

18B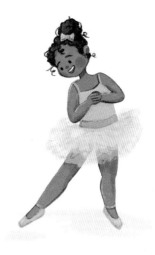

19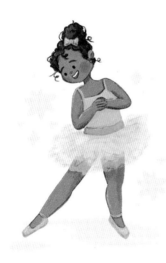

20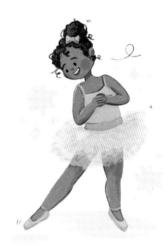

18. Now go to your sketch layer and duplicate it by swiping right over the layer and tapping "Duplicate." Turn one of these sketch layers' visibility off and change the other one's blend mode to Vivid Light. Bring the opacity up to 50%, and use your eraser to erase any lines you don't want to see in the final illustration. Duplicating the sketch means you can erase a section on one of them without messing up your original sketch. This is a little trick I like to use to make fast line art that looks sketchy and natural.

19. Create a new layer above this edited sketch layer and use your Oberon brush in a light pink to color your sparkles.

20. Create another layer at the top, and use your 6B pencil to add squiggles and lines to create motion in the illustration to make it look more dynamic and alive.

21

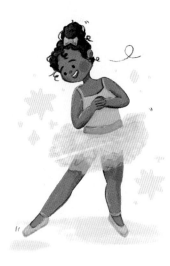

22

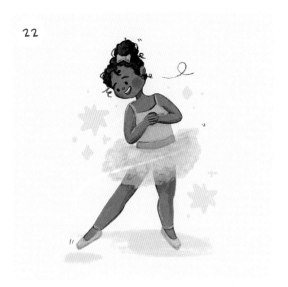

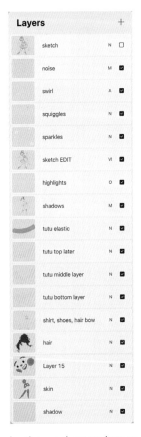

Layers		+
sketch	N	☐
noise	M	☑
swirl	A	☑
squiggles	N	☑
sparkles	N	☑
sketch EDIT	VI	☑
highlights	O	☑
shadows	M	☑
tutu elastic	N	☑
tutu top later	N	☑
tutu middle layer	N	☑
tutu bottom layer	N	☑
shirt, shoes, hair bow	N	☑
hair	N	☑
Layer 15	N	☑
skin	N	☑
shadow	N	☑

*In the end, your layers
will look like this.*

21. Above this squiggles layer, create a new layer and use a light yellow and your Oberon brush to make a swirl over your ballerina. Set this layer's blend mode to Add, bringing the opacity down to 10%.

22. Create a final new layer at the very top. Choose a medium pink, go to the Adjustments menu and tap "Noise." Slide your pencil to the right over your screen to 5%. Set this layer's blending mode to Multiply.

CHAPTER SIX

Flowers and Plants

In this chapter, we will take a look at how to draw flowers and plants, along with some tips and tricks to simplify their complex shapes.

As we've already discussed, all objects, including trees, plants and flowers, can be broken into basic shapes. If you take a close look at flowers and leaves specifically, you'll see lots of circles, ovals and teardrops. Petal shapes are also sometimes named after everyday objects like cups, trumpets, funnels, bells and spikes.

The best way to get familiar with plants is to really LOOK at and study them. Whenever you are out and about and see a pretty flower or tree, remember to take photos of them and save them to a "flowers and plants" folder. This way, you'll always have many reference materials to look at when drawing flowers and plants!

I also have a Pinterest account where I constantly save beautiful images into the broad categories I cover in this book.

How to Draw Flowers and Plants

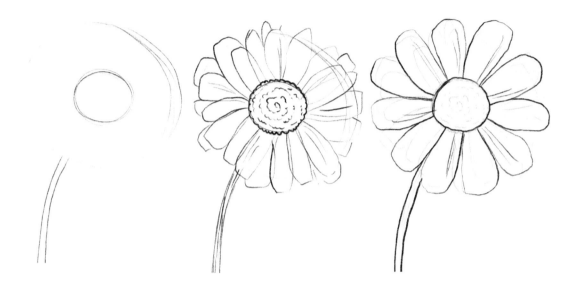

When you look at a reference photo of a flower, study the image carefully and lightly sketch the flower or plant using simple shapes.

Next, try to notice the details and unique features, lines and textures, and add them in. With this initial sketch, try to get the flower to look as close as possible to what it looks like in real life.

Now, lower the opacity of your rough sketch and draw another sketch on top of the first one. The point of this new sketch is to use the "realistic" sketch to simplify the flower's shapes as much as you can without losing the essence of it. With complex flowers, it sometimes means drawing fewer petals!

Here are more examples:

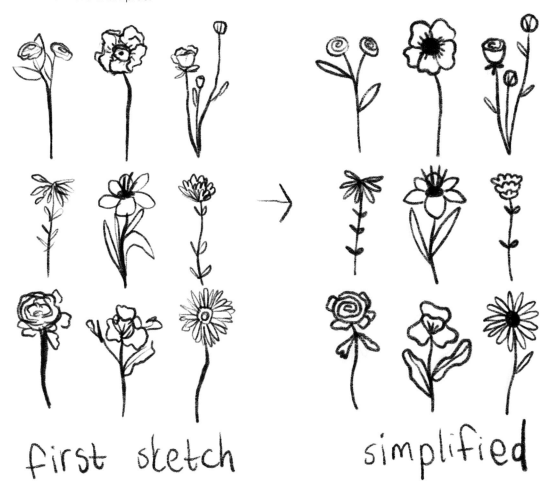

first sketch simplified

How to Draw Trees and Shrubs

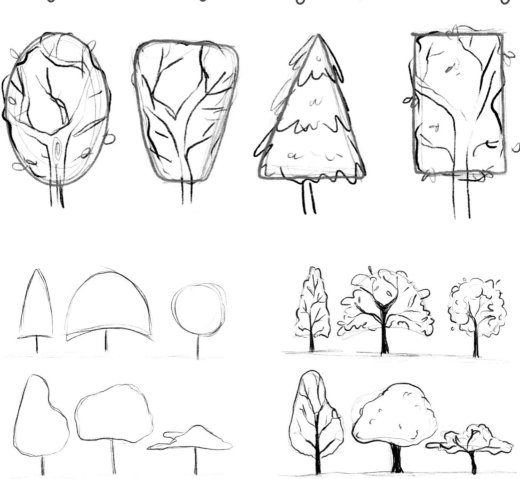

When drawing trees, start with big, simple shapes, and then add details and textures. The most common shapes for trees are ovals, triangles, cones and rectangles. You can also start with these simple shapes, and then give them a more organic shape.

A little trick I use for drawing trees is to think of them as oversized leaves! Start with a simple shape, add a "stem" or trunk and finish it off with "veins" or branches.

Flowers and leaves can really elevate portrait illustrations as well. Here are a few examples to get you started!

The process for drawing shrubs is the same as drawing trees. Start by drawing large, simple shapes, then fill in details and textures.

Project: Smiley Flowerpot

In this project, you will draw a colorful and happy smiling flowerpot filled with pretty flowers and leaves. This is the perfect opportunity to practice the concepts in the lesson about flowers and plants, with a super-cute result that you'll want to show off to all your friends and family.

BRUSHES

- 6B Pencil (in the Sketching tab)
- Chalk brush (in the Calligraphy section)
- Medium Nozzle brush (in the Spraypaints section)

TOOLS AND TECHNIQUES

- Clipping Masks
- Multiply and Overlay blend modes
- Opacity
- Noise
- Copy canvas
- Liquify

I

2A

2B

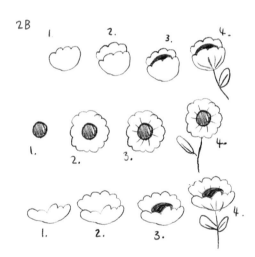

3

SKETCH AND DRAW

1. Start with a simple flowerpot.

2. Use the 6B pencil at size 20–30% to draw three flowers on a new layer above the pot. See Image 2B for a step-by-step on each of the flowers in this project. Each flower is at a slightly different angle to make it more interesting and dynamic.

3. Add some leaves and flower buttons behind the flowers on a new layer.

4

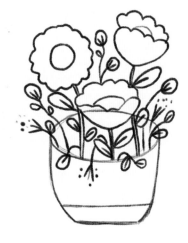

5

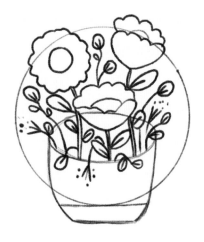

6

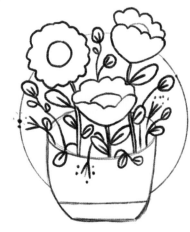

7

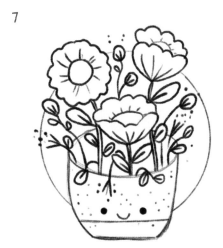

4. On the same layer, add some leaves in the foreground, including a few hanging over the front of the pot.

5. Draw a circular background on a new layer below all the existing layers.

6. Clean up your sketch using the eraser to erase any overlapping lines.

ADD DETAILS

7. Add details and textures like little specks on the flowerpot to indicate a rough pottery texture, or maybe some lines on the flowers to represent petals. Be sure to give your pot a cute smiley face.

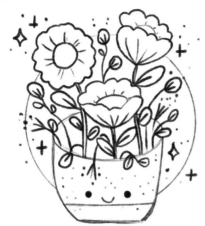

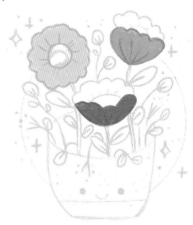

8. Finally, add some sparkles all around.

COLOR

9. Combine all the separate sketch layers into one single sketch layer. As always, all the color layers will be underneath the sketch layer.

10. Lower the opacity of your sketch layer to 25%, and create a new layer underneath it. Use the Chalk brush at size 40% (and bigger when you're painting larger areas) to paint all the base colors, each section on its own layer. For example, paint the front part of the flower on one layer. Then the back part of the flower on another layer.

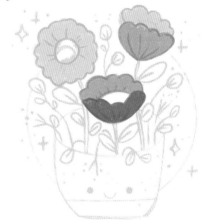

11A

	blooms	N	☑
	flower center	N	☑
	flowers front	N	☑
	flower center	N	☑
	flowers back	N	☑
	leaves	N	☑
	stems	N	☑
	pot color	N	☑
	pot	N	☑

11B

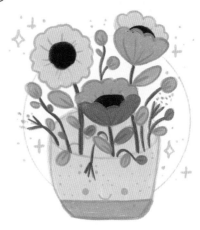

12

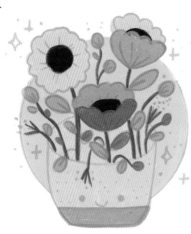

11. Continue this process until everything has a base color. Basically you're trying to put every element, or every different color, on its own layer. I also like to keep in mind overlapping elements. So, if I'm drawing lots of leaves, I'll separate the leaves into different layers so that nothing overlaps. This helps with a lot of things like easy recoloring and certain techniques for adding highlights and shadows. See 11A for what your layers should look like at this stage.

12. Add a background color.

13A

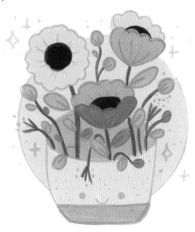

13B

14

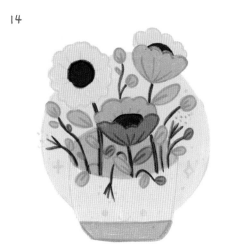

13. To add a darker color to the inside of the flowerpot, create a layer above the pot color, tap it and select "Clipping Mask." Now choose a color slightly darker than the pot, and color the inside section of the pot.

14. Set the blend mode of your sketch to Vivid Light.

15. Turn on Alpha Lock for each base color layer by swiping right over the layer with two fingers. Starting from the bottom, color-pick each base color and adjust the color to be slightly darker and more saturated, and then add some darker bits to each base color. Use the medium Nozzle brush (at size 45%) for this part. You're creating dark areas wherever shadows would fall if a light was shining from the top of the illustration to add depth to the illustration. The areas that are in shadow are the bottoms of the flowers, leaves and the pot.

15

16

17

18

19

16. Create a new layer above all the other layers, and set its blend mode to Overlay. Choose a light pink color, and use the Chalk brush to paint some highlights. Since you're imagining a light shining from the top, highlight the top edges of the flowers and leaves.

17. Lower the opacity of the highlights layer to 60%.

18. Create a new layer at the top, and set the blend mode to Multiply. Color-pick each base color to draw line art using the 6B pencil. Focus more on areas that fall in the shadows. You're drawing darker and thicker line art in this area to strengthen the shadowy areas of the illustration. Lower this layer's opacity to 50%.

19. Draw the pot's face and the sparkles on another new layer above all other layers.

20. Once again, create a new layer at the very top, and set the blend mode to Multiply. Use the eyedropper tool to select whichever color you're drawing on top of, and use the 6B pencil to draw scribbles. This is a great way to create texture, so the rougher the better. Lower the opacity of this layer if it looks too intense.

21. To get some scribbles on the background layer, create a new layer above your background layer, and set its blend mode to Multiply. Color-pick the background blue, and use the 6B pencil to make rough scribbles. Lower the opacity of this as well.

22. Finally, create a new layer at the very top. Tap the Adjustments menu, tap "Noise," and slide your finger over your screen to the right to add noise to 8%. Set the blend mode of this layer to Multiply.

23. Now, in the Actions menu, under Add, tap "Copy canvas." Then, create a new layer at the top. Tap the Actions menu again, and select "Paste." This will copy the entire image visible on your canvas as a flat image to this new layer. This is great if you plan to do any global adjustments.

24. If you feel that it's necessary to make minor adjustments to your illustration, go to the Adjustments menu and select "Liquify." Set the brush size to 50% and push things around the canvas until it looks right! I lifted the front of the flowerpot and evened out the sides. And you are done!

Layers			+
	liquify adjustments	N	☑
	noise	M	☑
	sketch	VI	☑
	texture and scribbles	M	☑
	sparkles	N	☑
	colored line art	M	☑
	highlights	O	☑
	blooms	N	☑
	flower center 2	N	☑
	flowers front	N	☑
	flower center	N	☑
	flowers back	N	☑
	leaves	N	☑
	stems	N	☑
	color	N	☑
	pot 2	N	☑
	pot	N	☑
	background texture	M	☑
	background	N	☑
	Background color		☑

In the end, your layers will look like this.

Animals

How to Draw Cute Animals

Most animals, specifically mammals (that includes humans), essentially consist of the same parts. Although they are laid out differently, they are still pretty much the same: head, neck, arms/legs, body and sometimes a tail.

When starting to draw animals, try to observe the most prominent, obvious shapes, and then fill in the rest from there. For example, cows are pretty much big rectangles with a triangular head.

But most animals can be broken down into circles and ovals.

When drawing line art, or coloring an animal, choose a brush and create brushstrokes that mimic the specific animal's skin or fur. Don't be TOO detailed; making a few spots for texture is better. A good rule of thumb is to put fur details in areas where the animal's body bends or folds.

As with most subjects, it's definitely best to learn by drawing from life. That way, you understand the topic at a fundamental level and can simplify or stylize your animals from there. Visit the zoo and take lots of photos, or search for images online.

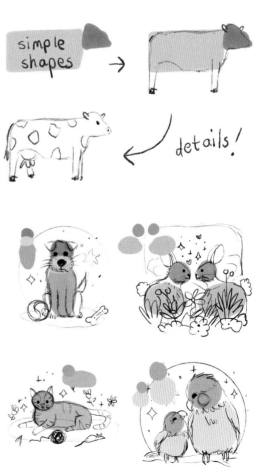

Observe an animal carefully before you start drawing. When studying their faces, pay attention to every part. For example, for the eyes, take note of the following:

- The size of the eyes
- Their distance apart from each other
- Whether they are deep-set into the eye socket or not
- What kind of shape the eyelids form around the eye

Do this for every part of the animal to properly capture their likeness.

Don't be too eager to get into all the little details of the animal. Focus on the larger shapes and the anatomy and be sure it looks correct before focusing on any specific animal details. The smaller details bring it all together, but they won't be enough if your large shapes aren't correct.

When you get better at drawing animals using real life or photos for reference, you can start playing around with stylization.

Project: Mama Hen and Her Little Chick

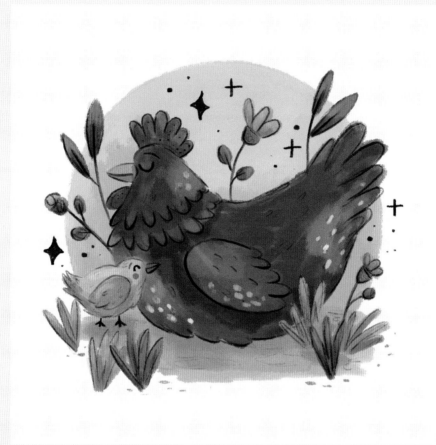

In this project, we will practice using what we've learned about using simple shapes to draw animals and create an illustration featuring a cozy mama hen with her fluffy little chick.

BRUSHES

- 6B Pencil (in the Sketching tab)
- Sassafras brush (in the Artistic tab)

TOOLS AND TECHNIQUES

- Quick shapes
- Transform tool
- Color adjustments
- Clipping Masks

1

2

3

4

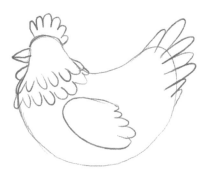

SKETCH AND DRAW

1. We'll use multiple layers to lay out the initial sketch before merging them into a final clean sketch. A chicken starts out looking pretty much like a bean. With the 6B pencil (size 20–30%), draw something that looks like a bean!

2. Add an indentation on one side for the head.

3. Draw her beak, comb and tail feathers.

4. Add little wings and fluffy neck feathers. Let her neck feathers stick out from the original bean shape to really emphasize their fluffiness.

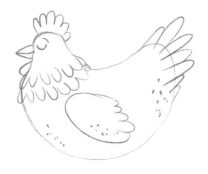

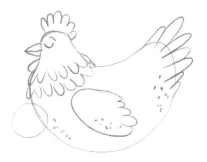

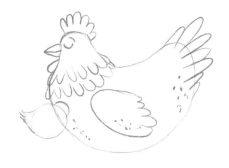

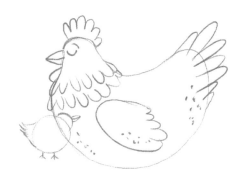

5. Add an eye and some speckles on her feathers.

6. Let's sketch the chick. A baby chicken is pretty much a puff of yellow feathers. So, start with a circle.

7. Add a little fluffy tail and a little bump for her head.

8. Add her tiny stick legs and beak.

9

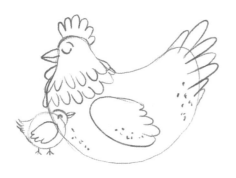

10A

10B

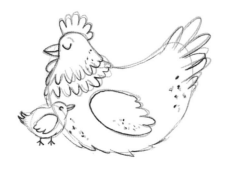

11

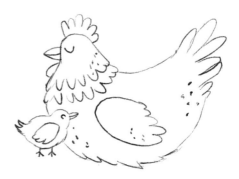

9. Draw her eye and wing. Baby chicken wings are proportionally bigger than adult chicken wings.

REFINE AND ADD DETAILS

10. Lower the opacity of the rough sketch layer, and create a new layer above it. Now, clean up your rough sketch by refining all the details.

11. Turn off the rough sketch. It's looking good, but let's make it cuter!

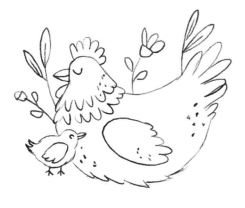
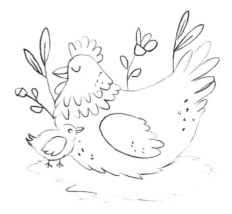

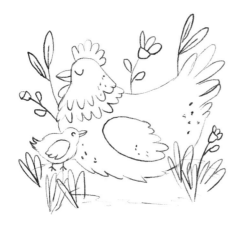
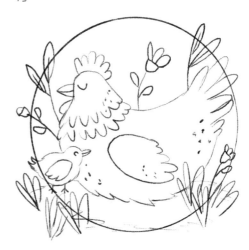

12. Draw a few simple leaves and flowers behind your chickens on a new layer below the clean sketch.

13. Draw a rough, curved shape below the chicken for the ground on this same layer.

14. Draw a few tufts of grass and a flower in the foreground on another new layer above the clean sketch.

15. Create a new layer below all the sketch layers, and make a circular background. Remember, you can draw a rough circle, wait a second or two for the quick shape function to activate and then tap on your screen to create a perfect circle. This is on a separate layer, so you can use the Transform tool to move the circle to the right spot.

16

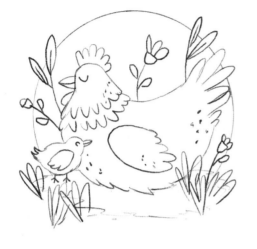

17

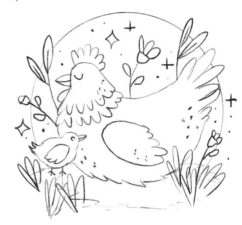

18

19

20

16. Once the circle is where you want it to be, use your eraser and erase the circle where it intersects with the plants or chickens.

17. Add a new layer above all the other sketch layers, and draw a few little sparkles here and there.

18. If you're happy with how everything looks, open your Layers tab and pinch all the sketch layers together in a single layer. You can rename it "Sketch." And now you're ready to add a bit of color!

COLOR

19. We are going to use this color palette. Lower the opacity to 20%.

20. Create a new layer underneath your sketch layer.

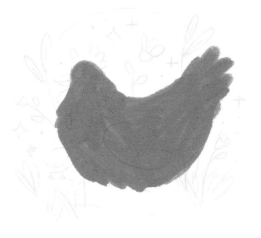

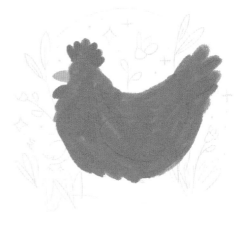

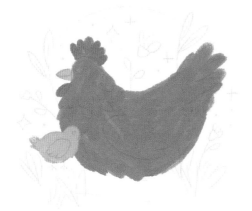

21. Start painting all the base colors. Grab the Sassafras brush and set the size to 15%. This is an ideal size for feathery textures. The Sassafras brush has lots of texture, and if you vary the pressure of your pen on the screen and lift it occasionally, you'll be left with a lovely feathery texture.

22. Create a new layer above the mama's base layer, and color her comb and beak.

23. Add the base color for the chick on its own new layer.

24. On a new layer below the chickens, add the background foliage. Use the 6B pencil to draw the stems of the flowers on the same layer.

27

	sketch	N	☑
	foreground foliage 2	N	☑
	foreground foliage	N	☑
	chick	N	☑
	hen details	N	☑
	hen	N	☑
	background foliage	N	☑
	ground	N	☑
	background	N	☑
	Background color		☑

28

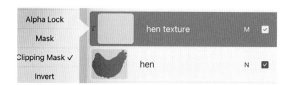

25. On a new layer above all the other colored layers, color the grass in front of the chickens.

26. Color the ground on a new layer below everything else and on another new layer below that—the background.

27. This is what your layers should look like at this point!

28. You will use Clipping Masks attached to each base color to add texture and details. It will look like this for each base color.

29. Long press to get the eyedropper tool, and select the color you used for the hen.

30. Use the Classic Color Picker to select lighter and darker versions of each base color. You can move the circle down and right for a darker, more saturated color. And then, move the circle up and left for lighter, less saturated colors.

31. Starting at the bottom, add a new layer above your first base color. In this case, the background layer. Tap on it and select "Clipping Mask." Then use the Sassafras brush to paint lighter and darker areas on the hen's body to create texture and add details.

32A

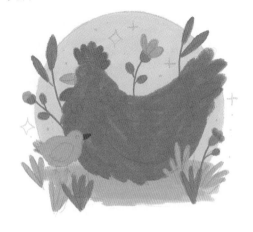

32B

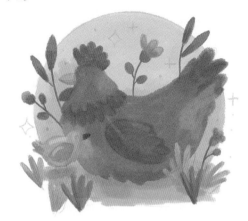

Before

After

32C	texture	N	☑
	chick	N	☑
	texture	N	☑
	hen details	N	☑
	hen body details	N	☑
	hen	N	☑

33

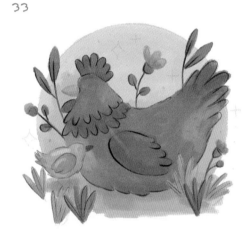

32. Create a Clipping Mask above each base color layer and add texture and details. Image 32C shows what your layers should look like.

33. Create a new layer above all the flat color layers, and set the blend mode to Multiply. Use the 6B pencil to fill in the line art on this layer. Use the eyedropper tool to select each base color when drawing on top of it. Draw all your colored line art on this same layer.

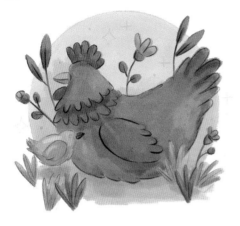

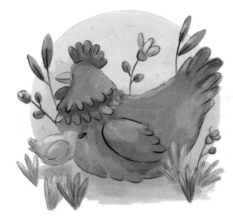

Before

34. Above the line art layer, create another layer set to Multiply. On this layer, you will paint shadows for the entire illustration. The easiest way to create simple shadows is to visualize a light source coming from any direction and "shining" onto the objects on your canvas. Paint shadows in areas that are hidden from the light source. So, with the hen, for example, shadows will fall underneath her beak, comb and wing as well as between some of her tail feathers. Do the same process you did with the line art layer. Eyedrop the base color when drawing shadows for that base color. Then, lower the opacity to 50%.

35B

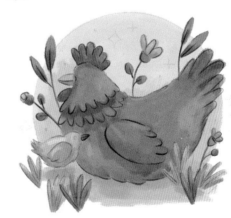

35. Create a new layer above the shadows layer, with the blend mode set to Overlay. This will be the highlights layer for the entire illustration. Choose a light yellow to paint a few highlights over the entire illustration. Remember to visualize a light source and how those light rays will hit the objects in the illustration. Things that are closest to the light, or stick out more than others, will have highlights. Turn the opacity down to 40%.

After

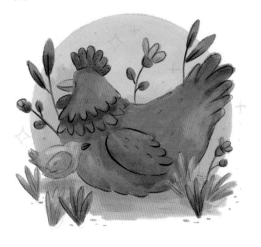

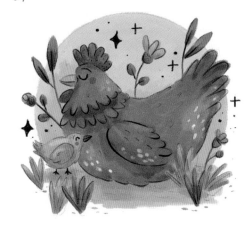

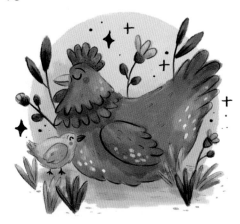

36. Above the highlights layer, create another layer set to Multiply. On this layer, you will draw textures. Textures are essential when drawing animals. So, on this layer, similar to the line art layer, use the eyedropper tool to select each base color when drawing the textures on top of that specific base color. Draw some "feather" textures over the chickens' bodies. Add some specs and dots here and there, along with a few scribbles.

37. Create a final new layer above all other layers, and draw the chick's legs and both chickens' eyes with the 6B pencil. Also, add a few sparkles all over!

38. Turn off the sketch layer. (Or set it to Vivid Light blend mode at 25%, as I like to do!) Zoom out and take a good look at the whole thing. A little trick I enjoy doing towards the end of the process is to go to Actions menu, under Add, tap "Copy canvas." Then, create a new layer at the top. Tap the Actions menu again, and select "Paste." Then go to the Adjustments menu, and choose the Hue, Saturation, Brightness tool. Turn the saturation slider all the way down, so you're left with a grayscale image.

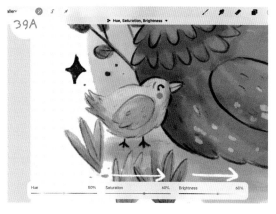

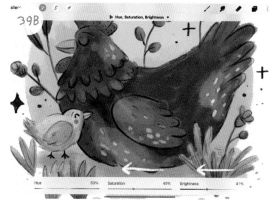

39. In grayscale, it's much easier to see what your illustration could do with a bit of extra contrast. In this case, you can see that there isn't enough separation between the mother hen and the chick, so things look just a little muddled in the color version. So, now, turn off the grayscale image layer, and select the layer that contains the chick's body.

Return to the Hue, Saturation, Brightness tool under the Adjustments menu and slightly increase the brightness and saturation. Then, select the layer that contains the mother hen's body and again choose the Hue, Saturation, Brightness tool, under the Adjustments menu. This time, slightly lower the brightness and saturation.

40. If you repeat step 38, you'll see that it looks much clearer in grayscale now. You can delete these layers when you're done!

41. Add a new layer above all your other layers for the final touch. Set its blend mode to Multiply in the Adjustments menu, choose "Noise," and then slide your pencil from left to right over the screen to set the noise level to 8%.

40

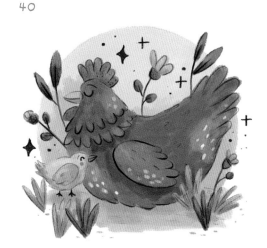

41

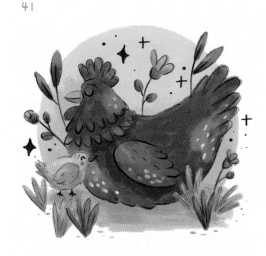

Project: Happy Puppy Portrait

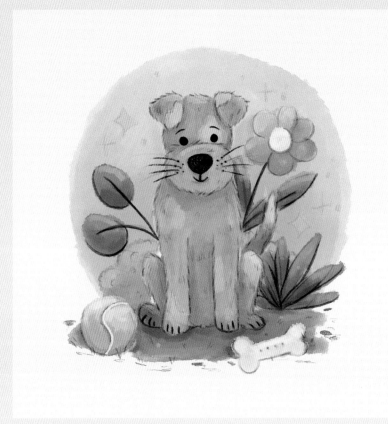

In this step-by-step project, you will continue to practice drawing animals, starting with simple shapes, and then adding details and textures. With this project, we're exploring different ways of adding highlights, shadows and texture, so get ready to try out some new methods!

BRUSHES

- 6B Pencil (in the Sketching tab)
- Larapuna brush (in the Artistic section)

TOOLS AND TECHNIQUES

- Alpha Lock
- Multiply and Overlay blend modes
- Noise

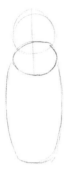

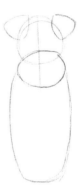

SKETCH AND DRAW

1. Start with a circle.

2. Draw an overlapping oval onto the bottom third of the circle.

3. Add another long oval shape to the bottom: the puppy's body.

4. Add two little ear shapes to the circle on top. This puppy has folded ears, and a folded-over dog ear looks very much like an upside-down puffy triangle!

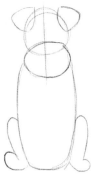

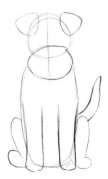

7

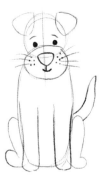

5. Add the two hind legs to the bottom of the body. When a dog sits down, and you're looking at them from the front, you're basically seeing the bend of their "knees" going down into their paws, which is essentially a small oval attached to the bottom of their leg.

6. Add the front legs and tail. Depending on the fluffiness of the dog, its front legs will cover most of its body, and you'll only see a little bit of its belly peeking out between its front legs.

REFINE AND ADD DETAILS

7. Add some cute facial features. All dogs have differently sized features sitting on top of differently sized and shaped heads and muzzles. (Dog muzzles include the nose and mouth.) This puppy has a large snout, and his eyes peek out just above the snout.

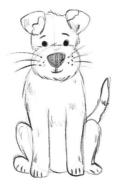

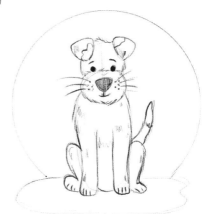

8. Lower the opacity of this rough sketch layer, and create a new layer on top of it. You will now work on refining the rough sketch a little. So, draw over top of your rough sketch and use short rough brushstrokes to look like fur. You can also add a few marks, spots and little scribbles over its body.

9. Add a little shadow or shape underneath the puppy to ground it and a circle to the back for the background.

10. Add more depth to your illustration by drawing leaves and flowers in the background and a couple of dog toys in the foreground. Finish it off with a few sparkles.

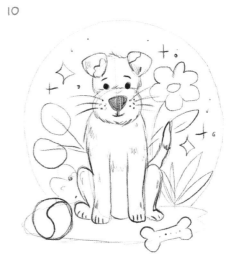

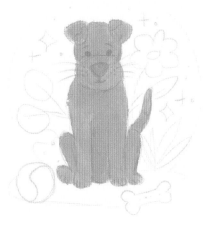
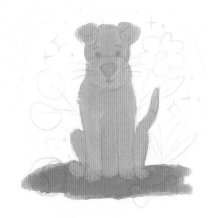

COLOR

11. Use a scraggly brush like Larapuna for this puppy portrait. This brush is pretty cool because it varies the opacity with the pen's pressure on the screen. Light pressure gives a low opacity, and more pressure gives higher opacity. So, you'll be able to create some nice textures with that, and texture is perfect when drawing fur. You'll use a simple neutral color pallet and add a few pops of color with the background elements.

12. Turn off your rough sketch layer, and then lower the opacity of your clean sketch layer to 20%. On a new layer underneath your sketch, start painting the flat colors of your puppy, with your brush at 30% or larger.

NOTE: When working with these kinds of brushes, remember to vary the pressure as you draw, change the direction of your brush-strokes and lift your pencil from the screen every few seconds. This is how you get nice textures and a natural look to the coloring. This specific brush is also very interesting because there's a slight color jitter every time you lift the brush, giving a very natural traditional art feeling.

13. Create a new layer below the base color of your puppy and draw the ground.

14. Create another new layer below the grass and add the sky/background color.

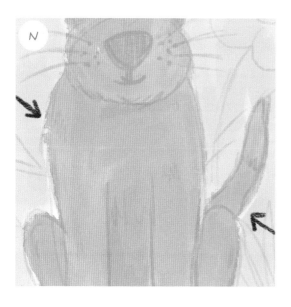

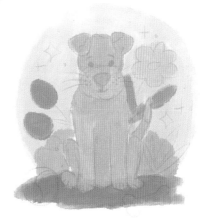

NOTE: When drawing on different layers, try not to overlap the different sections because the little gaps created between them give a perfect traditional art feel and a much more natural, realistic look. So in this specific example, drawing the background around the puppy will provide a much more realistic look than just doing a full flat background behind the puppy.

16

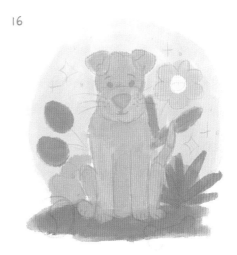

15. Create a new layer between the grass layer and the puppy layer. This layer will contain all of the background elements, flowers and leaves. Color everything on this layer that won't overlap with anything else.

16. Create a new layer above this background elements layer, and draw everything that appears in front of the things you drew in the previous step. In this case, it will be the spiky bush that sits in front of the other bush, as well as the round center of the flower.

17

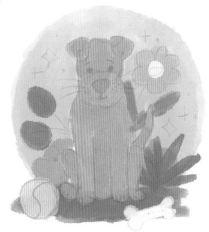

18

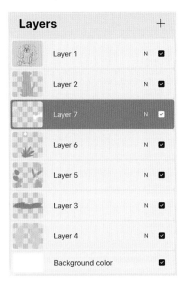

Layers		+
Layer 1	N	☑
Layer 2	N	☑
Layer 7	N	☑
Layer 6	N	☑
Layer 5	N	☑
Layer 3	N	☑
Layer 4	N	☑
Background color		☑

19

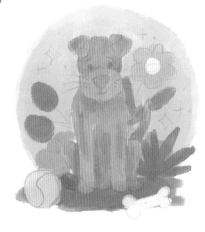

20

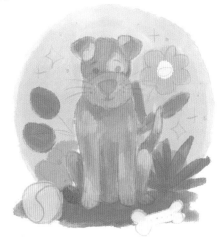

17. Add another new layer on top of that layer and draw anything that exists in front of the puppy: the foreground.

18. To turn on Alpha Lock, open your layers tab and swipe with two fingers to the right over each layer.

19. Start at the top and work your way down. So, in this case, we will start with the puppy's body. Eyedrop the color of their body and open your Classic Color Picker. Shift the little circle to a darker hue, and add a bit of darker color variation to the puppy's body.

20. Choose a lighter color, and add a few lighter areas to its body. Focus these lighter areas where you plan to draw markings on the puppy.

21

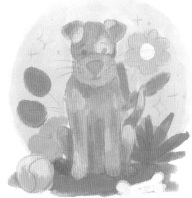

22

24

Layers +

	sketch	VI	☑
	puppy base	N	☑
	tennis ball & bone	N	☑
	flower leaves 2	N	☑
	flowers and leaves	N	☑
	ground	N	☑
	background	N	☑
	Background color		☑

23

21. At this point, it is good to trust the coloring process and know that while it might look "ugly" right now, it'll all get pulled together at the end. Repeat step 20 for all the other layers. A good rule of thumb is to try to add darker variation towards the shadow's end and lighter color closer to the light source.

22. Repeat this process for every base color.

23. Set the blend mode of your sketch layer to Vivid Light and change the opacity to 45%.

24. This is what your layers should look like at this point.

26

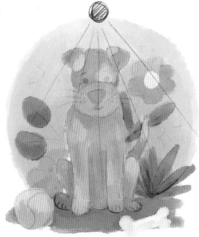

27

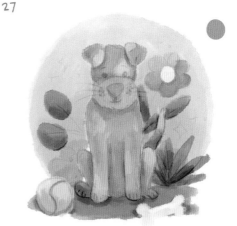

28

25. Now you're going to work on adding more contrast, depth and texture to finish this illustration by adding all the little details that will pull it all together and make it a final product.

26. Create a new layer above all the others, and set the blend mode to Multiply. On this layer, you will draw shadows for the entire illustration. Imagine a light source right at the center top of your illustration. Shadows will fall on the farthest part of each object from the light source. Highlights will fall on the closest regions of each object to the light source.

27. On the shadows layer, use the Larapuna brush and choose a medium blue color. Paint soft shadows all over, and draw sharper, more intense shadows wherever objects intersect.

28. Lower the opacity of your shadows layer to 70%.

29. Create a new layer above your shadows layer and set the blending mode to Overlay. Pick a light buttery yellow, and draw highlights over your entire illustration. Remember the light source from the previous step, and paint highlights on the parts of each object in your illustration closest to the light source.

30. Lower the opacity of your highlights layer to 70%.

31. Create a new layer above your highlights layer, pick a dark gray color and use your 6B pencil to draw the puppy's facial features. On the same layer, choose a dark green to draw the flower stems and leaves.

31

 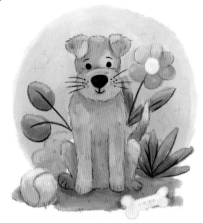

32. Above the face layer, create another new layer and again set the blend mode to Multiply. Use the 6B pencil to add some colored line art. You'll eyedrop each base color to draw lines on that base. When drawing lines for your puppy, use short, scraggly lines to represent fur. Also, add a few scribbles on its body.

33. Repeat this process for the rest of the illustration, keeping in mind the texture of the item you're drawing and adjusting the type of line you draw to represent that texture. For example, leaves are smooth, so they need straight lines, and tennis balls are fuzzy, so your lines can be squiggly. I also use varying opacity and concentrate the lines more on the shadow side of the object I'm drawing. Lower the opacity of this layer ever so slightly if it looks too intense. I turned mine down to 75%.

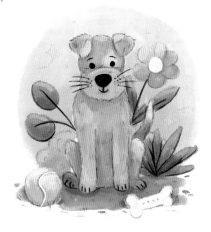 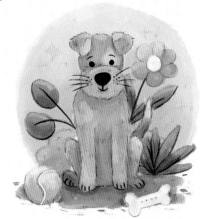

34. Create a new layer above this line layer for all the final details. On this layer, you're just going to add toes, the white stripe on the tennis ball and maybe a few darker lines where we need a bit more contrast. Don't forget some sparkles. Use the 6B pencil for details and the Larapuna brush for the sparkles.

35. Above all the layers, including the sketch, create a new layer and set its blending mode to Multiply. Go to the Adjustments menu, and tap "Noise." Drag your pencil to the right over your screen to about 8%. A noise layer adds an appealing texture to your entire illustration. And you're done!

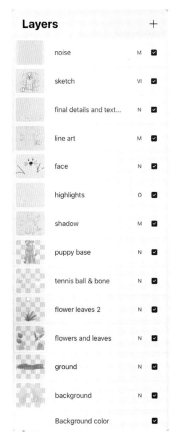

Your layers should look something like this.

Landscapes and Scenes

How to Draw Landscapes and Scenes

Landscape, background or environment drawing is another incredibly complex topic, but I have a few simple tips to create backgrounds that elevate your illustrations!

As with drawing anything else, use reference images. Referring to real life will always give much better results than trying to create something brand new in your mind.

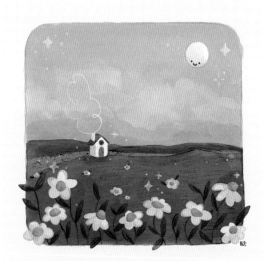

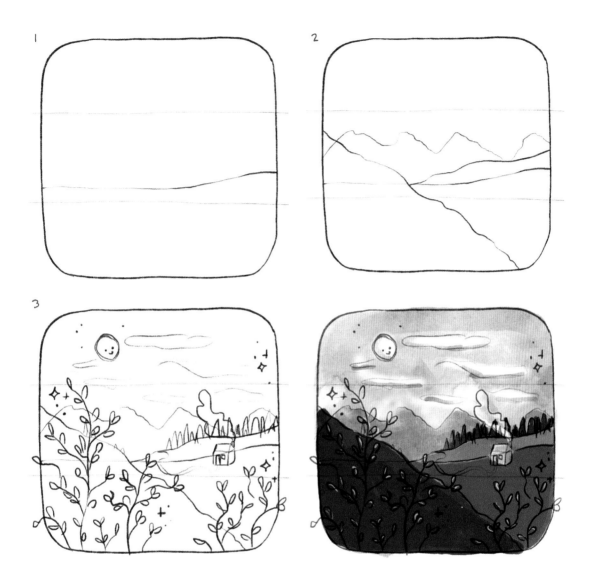

Here's a simple recipe you can use:

1. Split your canvas into thirds and place your horizon on the lower or upper third. You can also set the horizon on the middle line, but working from the upper or lower third is usually more interesting.

2. Start with big shapes, and work toward the finer details layer by layer. Draw your horizon, add mountains in the background, sloping hills to the foreground and another layer in the midground. Have fun with it!

3. Finally, draw all the smaller details over the big shapes. You can add a little cottage or some animals. Draw different kinds of trees and plants or even flowers! Add them to the background, midground and foreground.

And voilà! You've got a simple landscape!

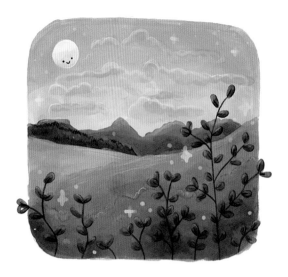

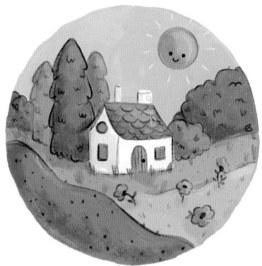

You can take this exact same concept and completely change things up by drawing differently angled hills and mountains. You can also change the look of your illustration by changing the time of the day—a sunny landscape will look much different than the same scene at night with the Moon and stars!

You can also create different focal points to enhance your landscape, like maybe a little cottage, an animal, a car, a pond, a river or a walking path—anything!

The focus of an illustration usually takes place in the midground. Background objects are faded and appear smaller, while anything in the foreground frames the illustration and guides your eyes to the points of interest.

Project: Peaceful Mountain Landscape

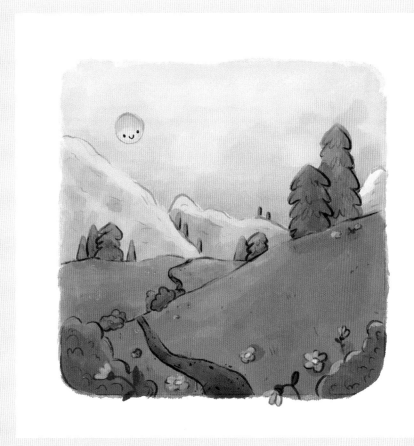

In this project, you will draw a landscape and make it cute! This illustration shows that even simple scenes can look impressive and exciting when you use the right color palette and brush—in this case, some soft greens, yellows and pinks, and a painterly brush called Quoll.

BRUSHES

- 6B Pencil (in the Sketching section)
- Quoll brush (in the Artistic section)

TOOLS AND TECHNIQUES

- Quick shapes
- Grid function
- Color adjustments (curves)

SKETCH AND DRAW

1. You're going to box your landscape by giving it a border on the canvas. So, start by drawing a square and centering it on your canvas. Remember that you can use quick shapes by roughly drawing a square on your canvas and holding your pen on the screen until it creates a clean shape. Then, while still keeping your pencil on the screen, tap on the screen with another finger to make a perfect square.

2. Draw round corners on your square and erase the sharp tips.

3. Draw a wavy diagonal line. This will be your foreground.

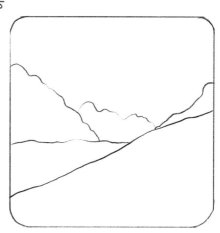

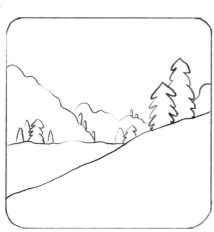

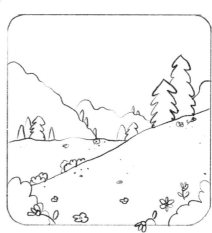

4. Draw a straighter horizontal line as your middle ground.

5. Draw mountains in the background.

ADD DETAILS

6. Start bringing your landscape to life by adding some trees. Add bigger trees on your foreground line and smaller trees on your background line.

7. Add some flowers and shrubs to the foreground and midground.

8

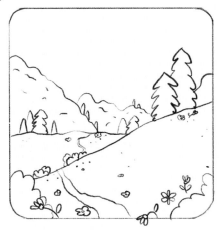

9

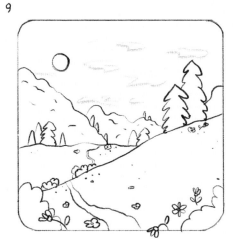

10

11

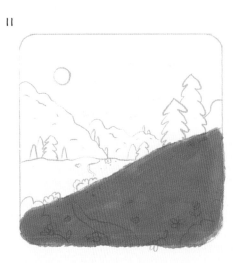

8. If you want, add a footpath and more detail to the mountains.

9. Add the sun and clouds.

COLOR

10. The Quoll brush (at size 5% and larger if necessary) is perfect for coloring a landscape. As always, we'll stick to a limited color palette.

11. Lower the opacity of your sketch layer to 25%, and then create a new layer below. Use the darker green color and start painting the foreground. With a brush like this, keep lifting your pencil periodically and varying the direction of your brushstrokes to build up color and texture.

12
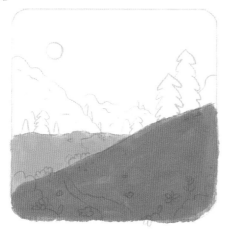

13
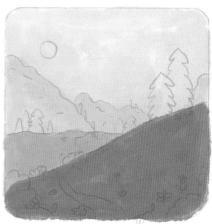

14
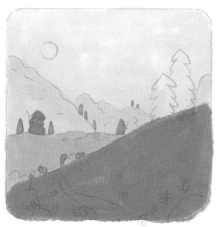

15
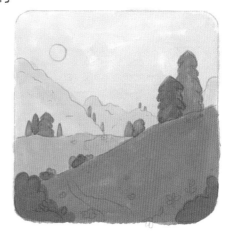

12. On a new layer below the foreground layer, paint the midground the same way, using a medium green color.

13. On a new layer below the midground, paint the mountains the lightest green color. Create another new layer underneath the mountains layer, and paint the sky light blue.

14. Create a new layer above all the other base colors (but below your sketch). Use dark green to start adding trees. Try to color in some of the trees without overlapping other trees. This will enable you to adjust certain trees if you find they need more contrast at the end.

15. Create a new layer for the rest of the trees and shrubs.

16

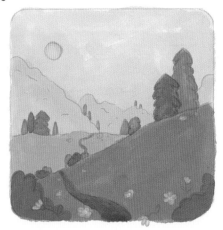

17

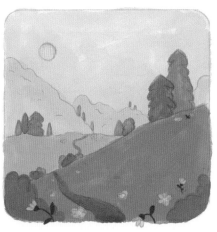

18

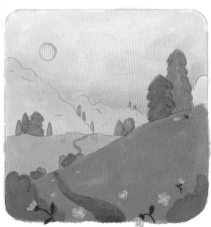

19

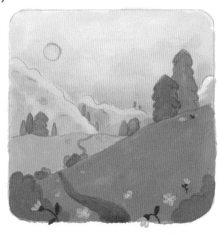

16. Add another layer on top of all your other color layers, and add the path, flowers and sun.

17. On a layer below the flowers, use a dark green and the 6B pencil to create stems and leaves.

18. Start at the bottom of your layers and add detail and depth as you go. On the sky layer, use the Quoll brush to color the sky. Use light pressure and squiggly motions to create rough

cloudlike shapes. Start with pink, and then use a little bit of yellow.

19. For the mountains layer, turn on Alpha Lock by swiping to the right on the layer with two fingers. Long press on the mountains to get the eyedropper tool to pick the colors. Use the Classic Color Picker to choose a lighter, less-saturated version of the color, and then paint the tops of the mountains. Then, choose a darker version to paint the bottoms of the mountains.

20

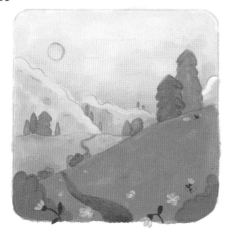

21

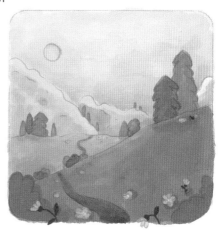

22

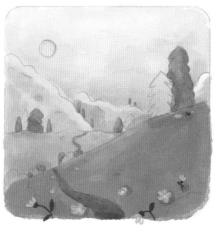

23

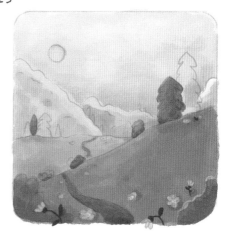

20. Now do the same thing for the middle ground layer. Turn Alpha Lock on for the layer, choose a lighter and darker version of the base color and paint it lighter closer to the light source and darker farther away from the light source, as well as any areas with overlap or shadows.

21. Do the same process for the foreground.

22. Repeat the same process for the trees and details. When you're doing the trees, a little tip is to turn off one of the tree layers so you can easily see which trees you've drawn on that layer.

23. Repeat the process with the other tree layer.

24

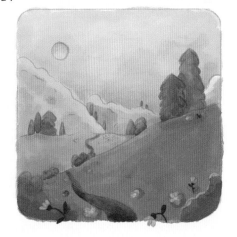

25

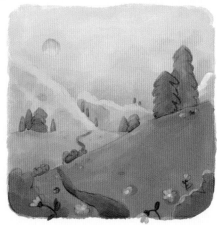

26

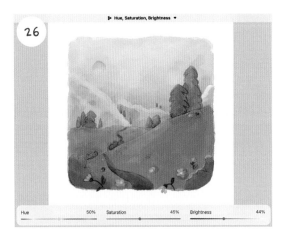

24. Finally, do the same thing with the layer that contains the walking path, sun and flowers.

25. Change the blend mode of your sketch layer (which should be at the very top of your Layers list) to Vivid Light. Set the opacity to 28%.

26. Take a good look at the entire illustration. I think it's safe to say that the midground needs to be a bit darker. So, select your midground. Tap the Adjustments menu, and then the Hue, Saturation, Brightness tool. Bring both the brightness and saturation down to 45%.

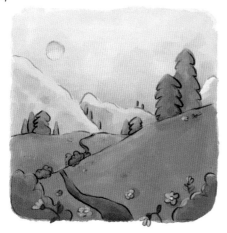

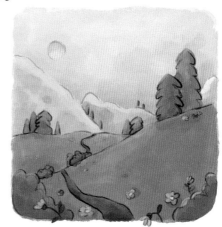

27. Now you're going to draw the final touches by adding line art and texture! Create a new layer below your sketch layer and above all the color layers, and set the blender mode to Multiply. Choose the 6B pencil and eyedrop each base color to draw defining and contrasting lines over the entire illustration. You can add these wherever you feel that the illustration needs more clear separation between sections or areas where the elements could do with more defined edges and borders.

28. Lower the opacity of that layer to about 60%.

29. Create a new layer above this line art layer for textures. Set this layer's blend mode to Multiply and the opacity to 60%. Color-pick each base color and draw lines and scribbles over your entire illustration.

29

30

31

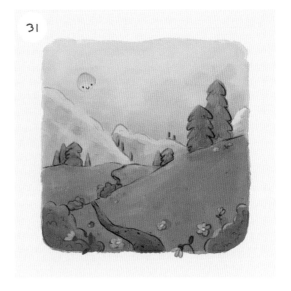

Layers +

	noise	Cb	☑
	sketch VL	Vl	☑
	:)	N	☑
	details and textures	M	☑
	line art	M	☑
	path, sun, flowers	N	☑
	flower stems	N	☑
	trees 2	N	☑
	trees 1	N	☑
	New group	∨	☑
	foreground	N	☑
	middle ground	N	☑
	background mou...	N	☑
	sky	N	☑
	Background color		☑

Here's what your layers should look like.

32

30. Now you can draw a cute little smiley face on the sun if you like.

31. Finally, create a new layer above every-thing, go to the Adjustments menu, select "Noise," and slide your pencil to the right over the screen to 8%.

32. Set the blend mode of your noise layer to Color Burn, and lower the opacity to 75%.

Project: Pink Forest Cottage

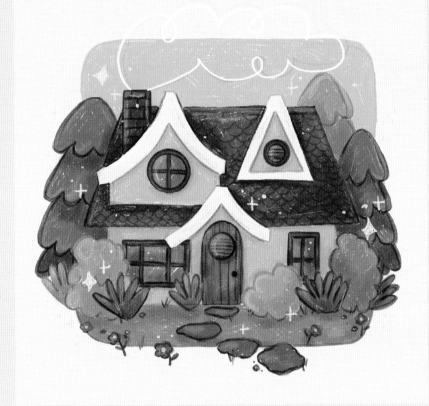

Here you will create a cute little cottage and surround it with trees and shrubbery. You'll be using elements of what you've learned in this chapter (page 132) and the Flowers and Plants chapter (page 91), and you'll bring it all together for your cottage. You will also use Procreate's drawing guide feature to keep the lines of your cottage balanced and straight.

BRUSHES

- 6B Pencil (in the Sketching section)
- Soft Pastel brush (in the Sketching section)

TOOLS AND TECHNIQUES

- Drawing Guide
- Quick shapes
- Alpha Lock
- Multiply and Overlay blend modes

SKETCH AND DRAW

1. Tap the Actions menu, and turn on the Drawing Guide. Now, tap "Edit Drawing Guide" and slightly lower the opacity.

2. Start with a rectangle. You can draw it roughly, and keeping your pencil on the canvas invokes quick shapes to make it a perfect rectangle.

3. Draw the roof shape, which is a trapezoid.

4. Add gables to the roof.

5

6

7

8

5. Erase intersecting lines until you're left with something like this.

6. Add a door and some windows. Different window shapes give a cute and quirky look! You can use quick shapes again for this part!

7. Add window frames and more details to the roof and door. Also, add the chimney. A chimney is a must for a little cottage!

8. Add some trees in the background on a new layer below your sketch. I like to use different colors when drawing different background elements to keep track of the layering.

9. With a different color, add shrubs and a stepping stone path.

10. Again, add a few more plants and flowers with another color.

11. Add a square with rounded corners to the background.

12. Add grass, and then some smoke coming out of the chimney.

13

14

13. If you're happy with how everything looks, pinch together all the separate sketch layers and Alpha Lock the layer by tapping on the layer and tapping "Alpha Lock." Choose any large brush and a dark gray color, and recolor all the lines.

14. Use the eraser to erase overlapping lines to make things look cleaner. But don't spend too much time on this—it doesn't need to be perfect.

COLOR

15. Now you're finally ready to start coloring! This time you'll be pencil coloring using a pretty color palette like the one in the example.

16. Change the blend mode of your sketch layer to Multiply. Lower the opacity to 20%. Create a new layer underneath the sketch layer.

17. With the 6B pencil, color each separate element of your drawing on a new layer.

15

17

18

Layers +

	sketch	M	☑
	smoke	N	☑
	grass and stems	N	☑
	flowers and rocks	N	☑
	shrubs 2	N	☑
	shrubs 1	N	☑
	door	N	☑
	window frames	N	☑
	windows	N	☑
	roof	N	☑
	house	N	☑
	trees 2	N	☑
	trees 1	N	☑
	sky	N	☑
	grass	N	☑

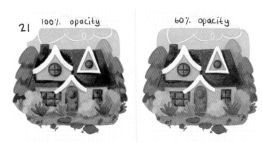

21 100% opacity 60% opacity

18. When coloring with a pencil brush, you want to try to keep it imperfect. Those visible brushstrokes and little gaps create a beautiful texture and a natural look!

19. Once you've added all the base colors for your illustration, your layers should look like this.

20. Create a layer above all your base color layers, and set its blend mode to Multiply. Use the Soft Pastel brush at 5 to 10% to paint shadows over the entire illustration. Draw the shadows for each element in their same base color.

21. Lower your shadows layer's opacity to 60%. So, to the left, you'll see that the shadows are pretty dark, and to the right, they are much subtler.

22

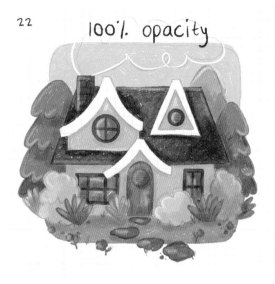

100% opacity

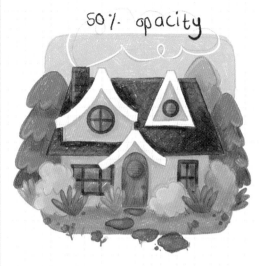

50% opacity

23

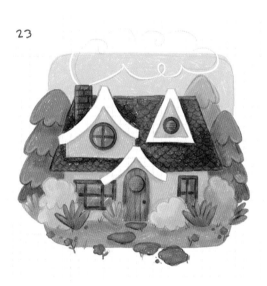

24

22. Create a new layer above your shadows layer and set the blend mode to Overlay. Choose a light yellow color and draw highlights over your entire illustration. When you're done, lower the opacity to 50%.

23. Create a new layer above your highlights layer and set its blend mode to Multiply. Use the 6B pencil to draw lines where the illustration needs more contrast. When you're done, lower the opacity to 50%.

24. Create a new layer and add some pencil marks over the illustration for extra texture. In this close-up, you can see that I've just used various random colors from the illustration itself to create texture.

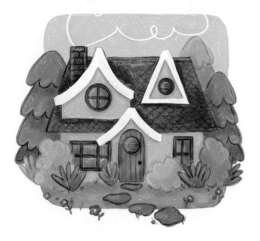

25

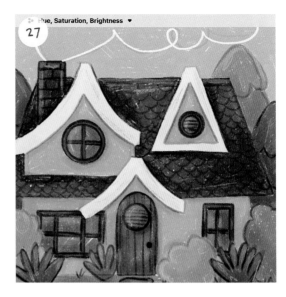

27

26

Saturation 60% Brightness 45%

28

25. Set the sketch layer to Vivid Light blending mode, bringing the opacity to 40%. At this point, you can also turn off the drawing guide.

26. Zoom out and look at the illustration. It seems like we could tweak the color balance a little. Search for the layer that contains the lighter colored shrubs. Go to the Adjustments menu and tap the Hue, Saturation, Brightness tool. Slide the saturation to 60% and the brightness to 45%.

27. Now, let's make some global adjustments. Create a new layer right at the top of all the other layers. Tap the Actions menu, and select "Copy canvas" (in the Add section). Tap the Actions menu again, and select "Paste." Your whole drawing should now be on the layer that you created. Go to the Adjustments menu and select the Hue, Saturation, Brightness tool. Bring the saturation down to 35% and the brightness to 48%.

28. Go to the Adjustments menu and choose "Curves." Tap right in the center of the diagonal line to create a new point.

29A

| Gamma |
| Red |
| Green |
| Blue |

29B

30

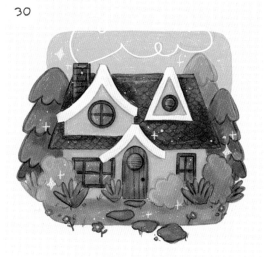

29. Now, bring the left corner point up slightly. This creates a subtler, more faded effect.

NOTE: This shows that thanks to digital art, you can always rescue and improve an illustration right at the end! If your final illustration turned out too dull and faded, you can do the exact opposite to brighten it up!

30. Create one last new layer right at the top. Choose a light, bright yellow, and add some sparkles everywhere. You can never have too many sparkles!

Project: Boy and His Puppy

In this final project, you'll take everything you've learned about drawing people, animals, plants and landscapes, and create a little scene of a boy and his puppy walking through the forest. You'll draw both characters and a simple background. You'll practice filling out a pretty background and create depth using foreground, midground and background.

BRUSHES

- 6B Pencil (in the Sketching section)
- Dry Ink brush (in the Inking section)

TOOLS AND TECHNIQUES

- Drawing characters using stick figures
- Clipping Masks
- Multiply and Overlay Blend modes
- Noise

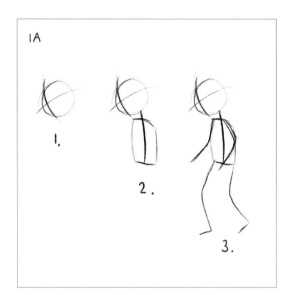

1A

1B

2

3

SKETCH AND DRAW

1. Start sketching with the 6B pencil in a dark gray color. Draw a rough stick figure of a boy walking, with a circle, and an angled cross to show a forward-facing head. Add the shoulders and hips, imagining a walking figure. You can also use a photo of a person walking for reference. Add his arms and legs. During this step, you should mostly be focusing on getting the proportions right. (Refer back to Create Characters Using Stick Figures on page 80 for more tips on getting this right.)

2. Now use a different color pencil, like red, to draw a rough doggy outline shape.

3. Lower the opacity of this stick figure layer and create a new layer above it.

4

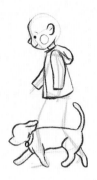

5

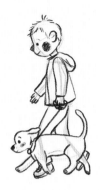

6

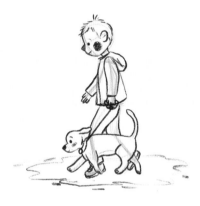

7

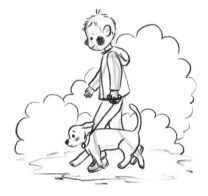

4. Start filling out your characters over the stick figures.

5. Finish the characters. When you draw zoomed out you don't have to be perfectly perfect! Focus on making sure that the large shapes look right and that the illustrations makes sense as a whole. When you're happy with it, you can start zooming into specific areas to refine certain elements and focus on smaller details.

6. Now let's start fleshing out the illustration. Start the midground on a new layer by adding the ground beneath your characters to ground them to something. Remember to make things easy to adjust, and add each background level to its own layer.

7. Draw some bushes on another layer below the midground.

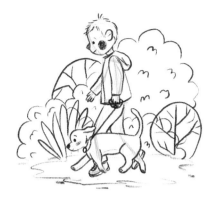

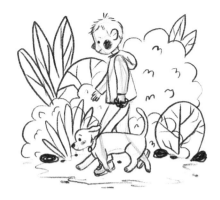

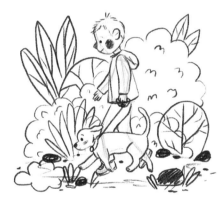

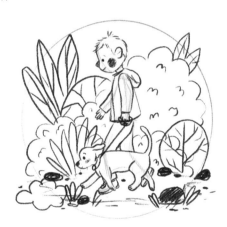

8. Add a few different leaf and plant shapes in front of and behind these first bushes.

9. Finish off the background by adding a final few leaves and some rocks.

10. On a new layer above the background, draw a few smaller shrubs, leaves, stones and flowers in the foreground.

11. Add a circle background.

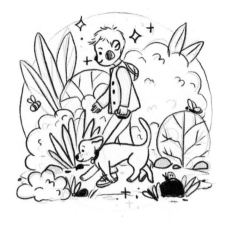
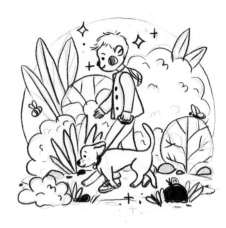

14

15

12. Add some sparkles, an oversized butterfly and a ladybug to round things out.

13. Once you're happy with everything, pinch your sketch layers together. Create a new layer and use the 6B pencil to draw over your illustration to clean and neaten things.

COLOR

14. Once again, you're going to keep your color palette simple because when it comes to color, simpler is better, especially when you're still figuring things out. Here is the color palette you'll be using.

15. Start by lowering the opacity of your sketch layer to 20%. Then start coloring underneath. Create a new layer underneath your sketch layer. Use the Dry Ink brush at size 30%. This brush gives full opacity but little imperfections, so you want to avoid going over areas more than once, so you don't lose any of the little imperfections in texture.

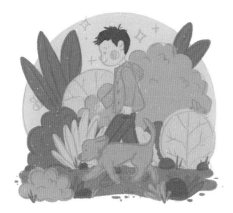

Layers +

	sketch	N	☑
	Layer 16	N	☑
	fg plants 2	N	☑
	fg rocks	N	☑
	fg plants 1	N	☑
	puppy	N	☑
	boy jacket	N	☑
	boy pants	N	☑
	boy hair	N	☑
	boy skin	N	☑
	bg plants 5	N	☑
	bg rocks	N	☑
	bg plants 4	N	☑
	bg plants 3	N	☑
	bg plants 2	N	☑
	bg plants 1	N	☑
	path/ground	N	☑
	sky/bg	N	☑
	Background color		☑

16. Once again, you will keep every element of your illustration on its own layer. Create a layer above your current layer if the element is in front of the section you're working on. Create a new layer below your current one if the element is behind the one you're working on.

TIP: Something that makes a subtle but noticeable difference is to constantly vary the brushstrokes to match whatever texture you're working on. For example, short and rough brushstrokes for fur. Long straight brushstrokes for smooth surfaces. Circular brushstrokes for curly hair or rough textures. Changing the direction of your brushstrokes to the direction in which something flows also creates a subtle but nice effect.

17. At this point, your layers will look something like this.

18

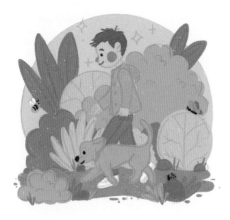

19

20

18. Now create a new layer for all the little details above all these layers.

19. Now you need to add shadows to each layer. Start with your path/ground layer at the bottom and create a new layer above it. Tap on the layer and choose a Clipping Mask, then set the blend mode of that layer to Multiply. Long press on the path color to select that color. Size the Dry Ink Brush all the way to 100%, and then draw shadows. Lower the opacity to 70%.

20. Now do the same thing on the next layer, the first layer of background plants. Create a layer above it and make it a Clipping Mask. Set its blend mode to Multiply and eyedrop the color of these leaves and draw shadows. Draw harsh dark shadows where objects intersect, and then tilt your Apple pencil slightly to create subtler shadows in other areas. Turn down the opacity to 70% or whatever looks good to you.

21

22

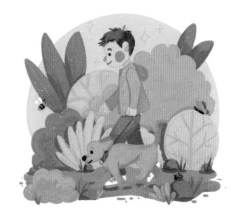

23	highlight	O	☑
	shadow	M	☑
	path/ground	N	☑

24

21. Now do the same process for all the rest of the background plants.

22. Continue going from the bottom to the top and add shadows to every layer in the same manner.

23. Go back to the bottom layer, create another layer above each base color, and set those layers' blend modes to Overlay.

24. Draw simple highlights using a light yellow and lower the opacity to 30 to 50%.

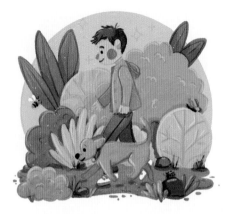
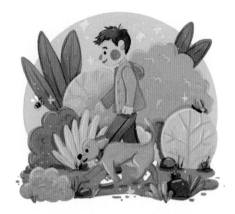

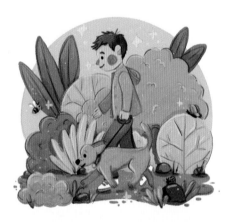
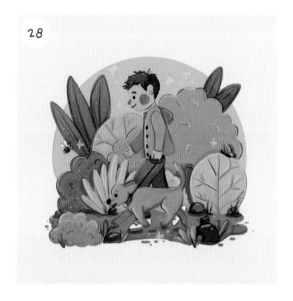

25. For some quick line art, set your sketch layers blend mode to Vivid Light and bring the opacity to 30%.

26. Create a new layer above all your layers and add a few sparkles.

27. Create a new layer above all the other layers. Choose a dark gray color, and draw a few lines to create contrast where needed.

You can add these lines in certain areas where objects overlap to make their separation clearer, as well as where objects need a more defined edge or border.

28. Create a final new layer above all other layers, and set its blend mode to Multiply. Choose a medium green color, and then go to the Adjustments menu, choose "noise" and slide your pencil over the screen to the right to 10%.

You've Made It!

Congrats! You've made it to the end of the book!

Now, it's time to set out on your own digital art journey. I hope you enjoyed the projects and can use what you've learned to create your own amazing art.

Remember, you are never done learning to draw. So, read more books, watch videos but most importantly—never stop practicing!

And in the end, one of the biggest joys of art is sharing it with other people. Don't be scared to put your work out there. You'll find an incredible community ready to cheer you on!

I would love to see any of your creations too, so please tag me on Instagram. You can find me at @rochewoodworthillustration.

Acknowledgments

Thank you to my superhero husband, Cody, who singlehandedly wrestled our three boys out of the house in the mornings to give me the peace and quiet needed to write this book! Whenever I felt overwhelmed, you cheered me on and made me feel like I could achieve anything. I wouldn't have been able to do this without you!

Thanks to my three boys, my biggest fans, for always overwhelming me with drawing requests. Your constant reminders that "Mama is the best drawer" kept me motivated! Love you Bo, Ben and Jamie!

Thank you to anyone and everyone who has ever encouraged my creativity throughout my life: my parents, grandparents, siblings, extended family, friends and teachers.

Thanks to the wonderful art community on Instagram, whose support and encouragement over the years is the whole reason I am here today, writing this book. I will be forever grateful for every like, comment and share given to me by strangers on the internet who gave me my platform and in return, every exciting career opportunity that has crossed my path over the last few years.

Thank you to Page Street Publishing for the opportunity to write this book and for everyone in the team that had a hand in the process. Mostly, thanks to Madeline for first reaching out to me and being the wonderful editor and motivator that you are! Your encouragement, kind comments and guidance throughout the process was a massive part in the making of this book. Thank you!

About the Author

Roché Woodworth is a South African digital artist most known for her cute and colorful illustrations on Instagram, all created during her babies' nap times!

Over the past six years, she's taken a fun hobby and turned it into a full-fledged art career. She creates drawing tutorials for beginners and resources for artists. She also loves taking on personal portrait commissions and creating fun digital downloads.

When she's not drawing, she's traveling and adventuring with her husband, all while raising their three young sons.

Index